CW00969415

Tomoko Sato

Alphonse Mucha

1860–1939

The Artist as Visionary

TASCHEN

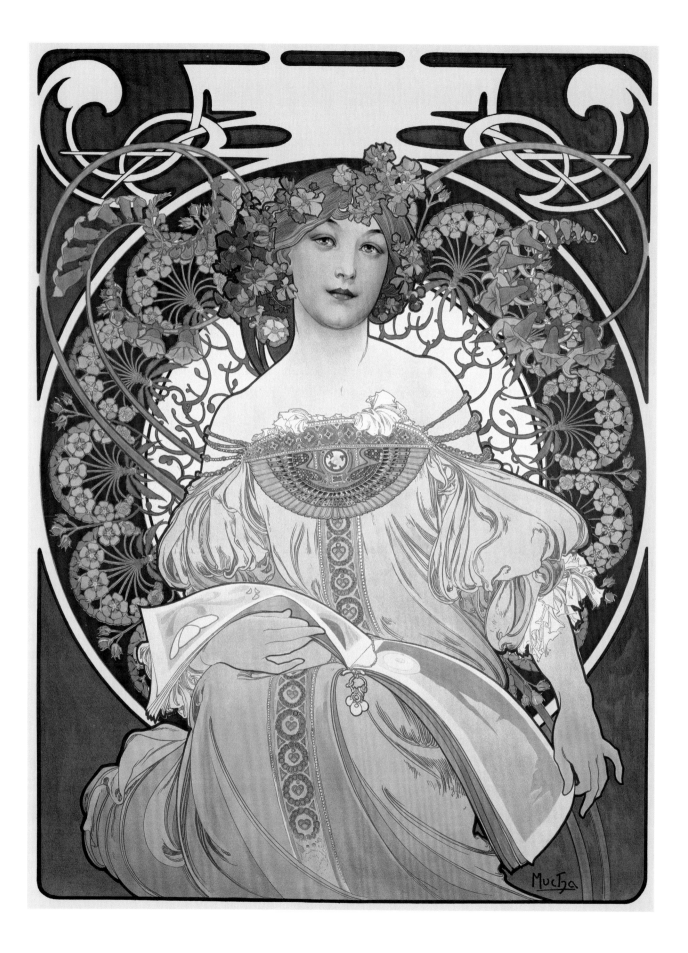

Contents

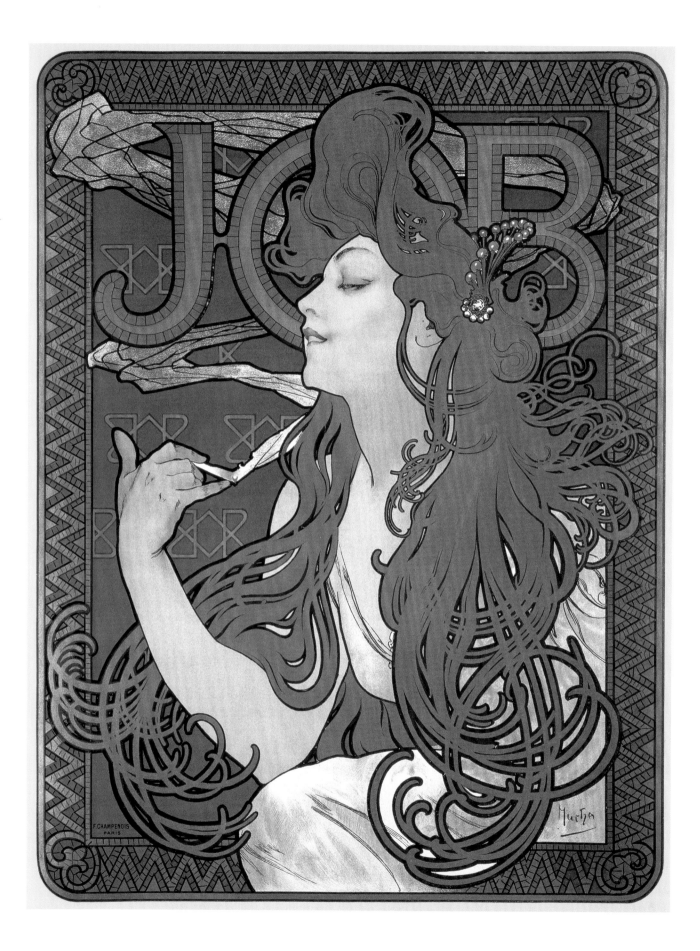

Moravia – the Beginning of a Journey

In the spring of 1904, Alphonse Mucha wrote to his family in Moravia shortly after his first transatlantic crossing to New York: "You must have been very surprised by my decision to come to America, perhaps even amazed. But in fact I had been preparing to come [here] for some time. It had become clear to me that I would never have time to do the things I wanted to do if I did not get away from the treadmill of Paris. I would be constantly bound to publishers and their whims … [In America] I don't expect to find wealth, comfort or fame for myself, only the opportunity to do some more useful work." Mucha was then at the height of his fame as one of the most sought-after artists in the French capital but at the age of 43 he abandoned his worldly success in order to pursue his ideal. Five years after his first trip to America, this 'more useful work' was to develop into an ambitious project to create a cycle of 20 monumental paintings depicting the history of all the Slavic peoples, which we know today as *The Slav Epic* (1912–1926). In 1928, on the 10th anniversary of the birth of his nation, Czechoslovakia, Mucha presented *The Slav Epic* to the city of Prague as a monument to inspire the spiritual unity of the Slavs and the peace of mankind. Mucha considered the work his most significant accomplishment as an artist and as a man.

Although Mucha is best known as a master of Art Nouveau, a close study of his life and work reveals a more complex side to the artist, especially as a socially committed thinker. He was a nationalist, a believer in Pan-Slavism, a Masonic reformer and a pacifist. For Mucha, art was a means to communicate his political and philosophical visions to the wider public, rather than to experiment with new doctrines and styles. The task of this volume is to examine the path of Mucha's life and to understand how his life shaped the art and the ideas behind his works.

Alphonse (or Alfons in Czech) Maria Mucha was born on July 24, 1860 in Ivančice, a small town in southern Moravia, then one of the Slavic provinces of the Austrian Empire. He was the fourth child of Ondřej Mucha (1825–1891), a court usher, and the first child of Amálie (*née* Malá, 1822–1880), a miller's daughter from Budišov, and Ondřej's second wife. Despite her humble origins, Amálie was unusually well read and before her marriage she had been the governess to an aristocratic family in Vienna. Mucha's birth was soon followed by the arrival of his two sisters, Anna and Anděla, and the large family lived in a

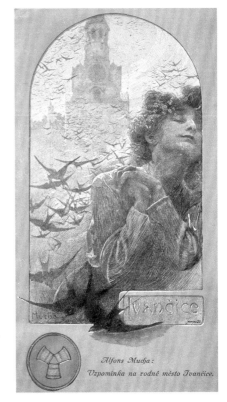

Memory of Ivančice, 1903
Reproduced as the postcard published in Ivančice, 1909
Postcard, colour lithograph, 14 x 9 cm / 5½ x 3½ in.

OPPOSITE
JOB, 1896
Colour lithograph, 66.7 x 46.4 cm / 26¼ x 18¼ in.

7

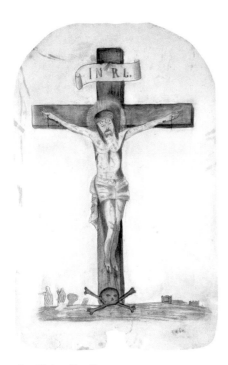

Crucifixion (detail), *c.* 1868
Pencil, crayon and watercolour on paper,
37 x 23.5 cm / 14⅝ x 9¼ in.

This is one of Mucha's earliest known works,
made when he was about eight years old. From
early childhood, the influence of the Catholic
Church, and especially its architectural beauty,
music and mystic atmosphere, had a great
impact on Mucha's sensibilities.

Choirboys at the Petrov Church,
Brno (detail), 1905
Watercolour on card, 24 x 23.7 cm /
9½ x 9⅜ in.

small residential quarter, sharing the same old stone building with the district
jail and adjoining the courthouse.

Ivančice was a quiet market town located approximately 20 km southwest of
the Moravian capital, Brno. Although its history was shrouded in war, foreign
invasion and religious strife – like many other towns in Central Europe – at one
time it was an important centre of Czech learning. During the Reformation, the
Unity of the Brethren, a religious sect advocating the Hussite movement, found-
ed a school and their main printing workshop at Ivančice and it was here that
they initiated the translation of the New Testament from the original Greek into
the Czech language. Known as the *Bible of Kralice* (the printing was done in the
nearby village of Kralice and published 1579–1593), this was to become the most
widely used Czech bible translation. Mucha later celebrated this achievement in
one of his *Slav Epic* paintings, *The Printing of the Bible of Kralice* (1914).

Such Czech learning, however, declined under Habsburg rule, which began
in 1620 with the victory of the Catholic Habsburg armies over the Protestant
Czechs at the Battle of White Mountain (Bílá Hora) near Prague. Catholicism
duly became the state religion, whilst the Czech language, indigenous religion
and culture were suppressed through Germanisation. By the late 18th century,
the Czech language had been reduced to no more than a folk dialect. A struggle
for national survival then began, and this effort, the Czech National Revival
movement, established to restore the Czech language, culture and national iden-
tity, reached its peak in the 1860s.

During the same period, the Austrian authority's hold over its vast, multina-
tional territory was weakening. In 1866, Austria was defeated by Prussia in the
Austro-Prussian War and lost its German states. Before Austria's subsequent
transformation into the Austro-Hungarian Empire in 1867, the immediate im-
pact of the war was felt even in Ivančice. During the summer of 1866, the town
was swarming with retreating Austrian soldiers and then occupied by the victo-

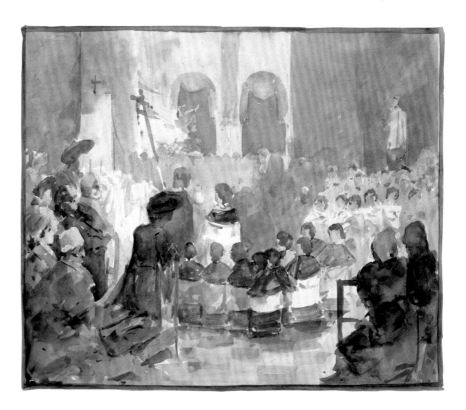

rious Prussian army for two months. The small community of Ivančice struggled to feed these more than 58,000 men and 14,000 horses. To six-year-old Mucha, the splendid display of the Prussian soldiers in their colourful uniforms looked like a scene from heroic ancient wars. However, when a cholera epidemic broke out, they turned into emaciated, yellowish corpses; the bodies were thrown in scores into mass graves outside the town. This experience had a lasting impact on Mucha and probably shaped his view of death and of the paradox of war, as depicted in works such as *War* (1916) and *The Slav Epic: After the Battle of Grunwald* (1924).

From a young age Mucha was keenly aware of life around him. "As a child I was continuously preoccupied with observing, even though I might have looked [as though I were] just gazing into a void", he wrote later. From flowers, a neighbour's dog, horses and monkeys to decorative patterns on local potters' wares and house decorators' paintings, objects and activities alike caught his eye. Fascinated by the way they looked and worked, he "faithfully noted everything that was out of the ordinary, whether by drawing or painting, or merely by being conscious of it." Being equipped with such a curious mind and a passion for drawing even before he could walk, he grew up to become an outstanding draughtsman. His portraits, caricatures and fantasy drawings impressed his schoolmates and teachers, and a local shopkeeper was so taken by Mucha's drawing that he often supplied the Muchas with free paper, even though it was a luxury in the small town without a railway.

In his formative years, religion played a considerable part in Mucha's life. His mother Amálie was a devout Catholic and young Mucha spent many years as an acolyte and choirboy at the Church of the Assumption of the Virgin Mary in Ivančice. Decades later in Paris, for the drawing *Memory of Ivančice* (p. 7), Mucha used the image of the church's Gothic tower as a metaphor for his love and longing for home and thenceforth it became a recurring motif in his work. When he was 11, his singing ability enabled Mucha to join the choir of the prestigious Cathedral of Saints Peter and Paul in Brno as a choral scholar. With this scholarship he was also able to receive higher education at the Slovanské Gymnasium in the city. The various impressions of the church from his religious upbringing – the grand edifice of a cathedral, its frescoes, statues, ornaments, burning candles, the intoxicating fragrance of incense and flowers, bells, singing and music – stayed with him throughout his life. Mucha wrote later: "For me, the notions of painting, going to church, and music are so closely knit that often I cannot decide whether I like church for its music or music for its place in the mystery which it accompanies."

Furthermore, the intensely patriotic environment created by the Czech National Revival movement nurtured adolescent Mucha's nationalist consciousness. As a student in Brno he witnessed a revived interest in Moravian folk art and culture among the intellectuals and students who opposed the influence from Vienna. He also met the composer Leoš Janáček (1854–1928), who was then deputy choirmaster at St. Thomas's Abbey, and a future leading exponent of nationalist expression in music. The number of Czech-language publications had been increasing since the 1860s, informing the latest political thinking and cultural trends in Prague, Brno and other regional centres. Works by eminent artists and musicians such as Josef Mánes (1820–1871) and Bedřich Smetana (1824–1884) were exemplifying how art could serve the nation through its power of inspiration. The highly influential Sokol movement was now spreading to Moravia and other regions, promoting nationalist ideology through physical and moral train-

***Portrait of Mucha's Sister Anna**, c.* 1885
Oil on canvas, 55 x 34.5 cm / 21⅝ x 13⅝ in.

This realist-style portrait of his sister, Anna, was painted while Mucha was a student in Munich. Among his family he was particularly close to her and the two of them regularly exchanged letters. In 1885 Anna married Mucha's friend Filip Kuber, a Czech patriot, writer and publisher; Mucha made many illustrations for Kuber's satirical magazines.

*Screen for the Emmahof Castle,
Mikulov*, c. 1883–1884
Oil on canvas, overall dimensions of the
triptych: 180 x 161 cm / 71 x 63½ in.
Brno, Moravian Gallery

ing. When he returned to Ivančice in 1877, Mucha had numerous opportunities
to be involved in patriotic activities, joining the Sokol, using his artistic skills to
design flyers and decorate halls for political events, while also being involved in
local amateur theatre and working as a stenographer at the district court.

In the cultural environment of Moravia in the 1870s, it was natural for Mucha
to perceive art as a means to respond to the nation's needs. In the autumn of 1878
he applied to the Academy of Fine Arts in Prague on the advice of Josef Zelený
(1824–1886), a painter and Mucha's drawing teacher during his student days
in Brno. Unfortunately, his application was unsuccessful and he was advised to
find "a different career" by the Art Academy. A year later, however, a news-
paper advertisement brought him a new chance: Kautsky-Brioschi-Burghardt, a
theatre-set company in Vienna, was seeking a painter for its workshop. Mucha
immediately responded to the advertisement and was offered a job as an appren-
tice scene painter. At the age of 19, Mucha set off for the capital of the Austro-
Hungarian Empire with a sense of mission for the future of his homeland.

Mucha spent almost two years in Vienna. A centre of high culture and a
world capital of music, the city offered him great opportunities to explore beau-

tiful churches, museums, art galleries, concert halls and, above all, theatres, thanks to the free tickets supplied by the company he worked for. In his spare time he could take evening art-classes and study the latest trends, especially the style of Hans Makart (1840–1884), the most fashionable painter in the Viennese art world. The 'Makartstil', which typically involved large, sumptuously coloured historical or allegorical paintings in complex compositions incorporating beautiful women, was highly influential among the academic artists and high society of Vienna. During this period, Mucha also began to take photographs with a borrowed camera, experimenting with this new medium of visual expression. He was to continue with photography throughout his life and it became an important part of his creative process. Unfortunately, however, his first taste of cosmopolitan life was short-lived. On December 8, 1881, a major fire broke out at the Ringtheater, killing almost 400 people and destroying the building. This theatre was the largest customer of Mucha's employers and the consequent loss of business caused him to lose his job.

For a while Mucha stayed in Vienna, until his savings were reduced to only five florins. He then decided to try his luck as an artist rather than going home straight away. Taking a train from the Franz Josef Station and going as far north as his remaining money would take him, he got off at Mikulov, a picturesque Moravian town on the border with Austria. Luck was on his side, and soon Mucha began to earn a reputation in this small town as a portrait painter, decorator and lettering designer for tombstones. His work caught the attention of Count Eduard Khuen-Belasi (1847–1896), a local landlord, which resulted in his commissioning Mucha to paint a series of frescoes for his residence, Emmahof Castle, and later his ancestral home in the Tyrol, Gandegg Castle, where his younger brother Count Egon (1849–1909) lived. The brothers were so impressed by Mucha's talent that they became his patrons, subsequently enabling him to receive formal art training in Munich and Paris.

The Counts' patronage provided Mucha not only with financial security but also the cultural and intellectual environment that contributed to the development of his artistic skills and consciousness as a professional artist. At Emmahof he was able to enjoy an elegant lifestyle and unlimited access to Count Eduard's library, where he could study Old Master paintings as well as drawings and illustrations by modern French artists such as Eugène Delacroix (1798–1863), Ernest Meissonier (1815–1891), Charles-François Daubigny (1817–1878) and Gustave Doré (1832–1883). Count Eduard also became Mucha's "great moral authority" and introduced him to the idea of Freemasonry, sowing the seeds of Mucha's future spiritualism. Furthermore, Count Egon was himself an amateur painter. He often took Mucha painting 'en plein air' in the Tyrolean Mountains and travelled with him to northern Italy, exposing him to artistic heritage in Venice, Florence, Bologna and Milan. Moreover, Count Egon decided to send Mucha to Munich, having been prompted by his old friend and Munich painter Wilhelm Kray (1828–1889), who had seen Mucha's work at Gandegg.

Mucha entered the Academy of Fine Arts (originally the Royal Academy of Fine Arts) in Munich in September 1885. One of the oldest and most prestigious art academies in Germany, the school attracted talented young artists from throughout the Habsburg territories as well as the new German Empire. During his two-year stay, Mucha formed lasting friendships with many Slavic students including his fellow Czechs Joža Uprka (1861–1940), Luděk Marold (1865–1898) and Karel Mašek (1865–1927), as well as the Russians Leonid Pasternak (1862–1945) and David Widhopff (1867–1933). With his nationalistic enthusiasm,

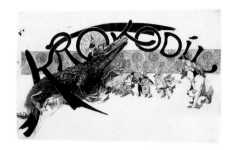

Krokodíl, 1885
Design for the heading of the magazine cover
Pen and ink on card, 20 x 32 cm / 7⅞ x 12⅝ in.

A principal contributor to *Krokodíl* and various other magazines published by Filip Kuber, Mucha was bombarded with his brother-in-law's requests for illustrations: "Dear Friend, I am writing to you again and hope you don't mind … The illustrations for *Krokodíl* and *Slon* which you sent me are already at the printer's." Mucha's design here demonstrates his innovative lettering style, an element that was to become fully developed with his poster designs in Paris.

Fantaz, 1882
Design for the magazine cover
Ink and watercolour on paper,
46 x 28.8 cm / 18⅛ x 11⅜ in.

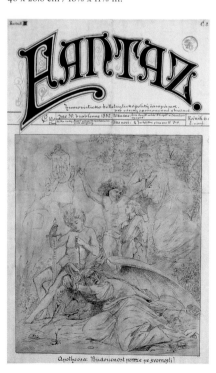

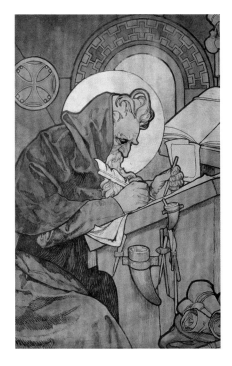

Writing Methodius and Philosopher Cyril, 1931
Studies for the stained-glass window in
St. Vitus Cathedral, Prague
Pencil, ink and watercolour on paper,
125 x 160 cm / 49 x 63 in.

Mucha's stained-glass window, funded by the
Slavia Insurance Bank (see pp. 74, 75), was made
in 1931, following completion of the Gothic
reconstruction work of the Cathedral in 1929.
This design was made for the upper left panels
of the window, portraying Methodius and Cyril
as a scholar and thinker respectively.

Mucha became a guiding light for the Czech art students' club Škréta, named
after the prominent Czech Baroque painter Karel Škréta (1610–1674). When
Mucha was elected its president, he expanded the membership to all other Slavs
studying in the city. Members published their drawings in the club's journal, *The
Palette*, as well as other Munich magazines and newspapers. Mucha also stayed
in close touch with his homeland, regularly contributing illustrations and de-
signs to the satirical political magazines *Fantaz* (p. 11 bottom), *Slon* and *Krokodíl*
(p. 11 top), all founded by his brother-in-law Filip Kuber (1858–1913).

Not many works are known from Mucha's Munich years but his large altar-
piece, *Saints Cyril and Methodius* (p. 12), is particularly noteworthy among the
surviving paintings from this period. The painting was produced for the Church
of St. John of Nepomuk at Pisek, a small town in North Dakota founded by
Czech settlers in America around 1880. Mucha's relatives were among these set-
tlers and they arranged for him to produce the work. Cyril and Methodius were
ninth-century Byzantine missionaries and Czech patron saints who had spread
Christianity among the Czechs and other Slavs. Mucha was to revisit this subject
later in one of the *Slav Epic* paintings, *The Introduction of the Slavonic Liturgy*
(pp. 76, 82 top), and in the design for the stained-glass window in St. Vitus
Cathedral in Prague (above). In the altarpiece he portrayed the saints in the
Classical pyramidal composition, combined with bold foreshortening as well as
rich colours and symbolism, clearly demonstrating his growth as a skilled aca-
demic painter. Mucha was now ready to take the next step in his journey. He
chose Paris as his next destination.

OPPOSITE
Saints Cyril and Methodius, 1886
Design for altarpiece in the Church of St. John
of Nepomuk in Pisek, North Dakota
Oil on canvas, 85 x 45.5 cm/ 33½ x 18 in.
Czech Republic, private collection

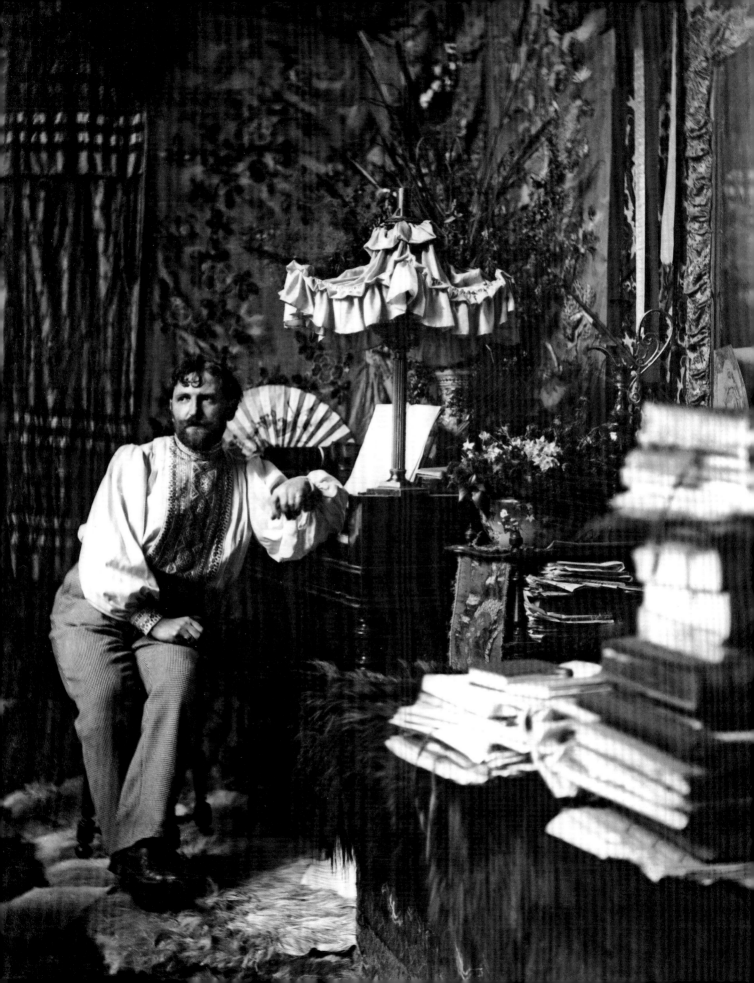

The Bohemian in Paris

In the autumn of 1887, Mucha arrived in Paris with his friend from the Munich Academy, Karel Mašek. As the heart of a rapidly expanding colonial empire, Paris was going through an economic boom, and its prosperity and confidence made the city the greatest capital of the arts in Europe, attracting young artists and students from every corner of the world. During this period, it also became common among Czech art students to study in Paris after training in Munich. On the first day of their arrival, Mucha and Mašek registered at the Académie Julian, where they were reunited with their friends from Munich, Luděk Marold and David Widhopff.

Located in the Passage des Panoramas off the Boulevard Montmartre, the Académie Julian was a private art school founded in 1868 by the artist Rodolphe Julian (1839–1907) as an alternative training centre to the government-sanctioned École des Beaux-Arts. With inexpensive tuition fees (an important factor for Mucha), tutors of a high calibre and an unconventional teaching policy which admitted female students who were then allowed to draw from nude male models, the school was popular with foreign students as well as young avant-garde French artists. Mucha's tutors included Jules Joseph Lefebvre (1836–1911) and Jean-Paul Laurens (1838–1921), both also professors at the École des Beaux-Arts and highly regarded art educators. Combined with Mucha's earlier influence by Makart, Lefebvre's allegorical compositions celebrating feminine beauty and Laurens's large historical paintings in theatrical settings are very likely to have contributed to the artistic direction he would take in later years. In addition, the Académie Julian provided Mucha with a new set of friends, especially Paul Sérusier (1864–1927) and his circle, who subsequently founded Les Nabis. As an aspiring 'thinking artist' with an ambition to work for his homeland using his art, Mucha was encouraged by their view of painting as a visual means to express the artist's private vision rather than to pursue art for art's sake. Furthermore, Mucha saw a parallel between his own nationalist approach to the use of art and their admiration of the folk traditions and rustic life in the Brittany village of Pont-Aven, and its inspirational source for their artistic creation.

At the time of Mucha's arrival, Paris was undergoing a radical transformation. The modernisation of the city, which had begun during the Second Empire (1852–1870), continued under the Third Republic from 1870 onwards, materialising most vividly in the construction of the Eiffel Tower, the symbol of a new age

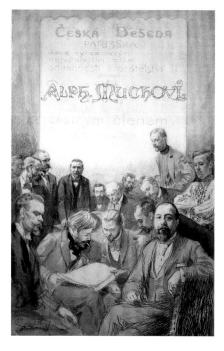

František Kupka
Alphonse Mucha, 1898
Study for the Diploma of the Czech Beseda in Paris, 1898
Pencil, ink, watercolour and crayon on paper, 54 x 35 cm / 21¼ x 13¾ in.

OPPOSITE
Self-portrait in Mucha's studio in the rue de la Grande Chaumière, Paris, 1892
Photograph from original glass-plate negative

Death of Frederick Barbarossa, 1898
Illustration for *Scènes et Épisodes de l'Histoire d'Allemagne* by Charles Seignobos
Published by Armand Colin et Cie, Paris

One of the 33 illustrations contributed by Mucha for this book, the picture shows the episode involving the Holy Roman Emperor Frederick Barbarossa (1122–1190), who drowned in the Saleph River. Placing his naked lifeless body on the river-bank amidst the gnarled old trees, Mucha captured the uncanny silence of the scene. An oil study of this illustration was among the works exhibited at the Paris Salon of 1894.

and new technology. From the rooftop of his apartment, Mucha was able to see the rapidly growing height of this iron structure, which was to be completed for the Paris Exposition Universelle of 1889. Consumer culture was thriving too. Le Bon Marché, the best-known department store in the city and which Émile Zola (1840–1902) had called "*Une cathédrale de commerce pour un peuple de client*", unveiled its new face in 1887, after refurbishment undertaken by Gustave Eiffel (1832–1923), the very same architect of the iron tower. The texture of Parisian society was also changing, with increasing numbers of immigrants arriving from the provinces as well as foreigners from France's overseas colonies and other parts of the world. The population of Paris grew from 1.9 million in 1872 to 2.4 million in 1891. Although the Czech population was small, with the focus of the Paris Beseda, a society founded in 1862 by an émigré group in the city to help new arrivals, the Czechs formed a close-knit community. As well as joining the Paris Beseda (see p. 15) Mucha set up the Lada club for young Slavic artists – not only Czechs but also Russians and Poles – whose numbers grew every month.

In the late autumn of 1888, Mucha moved to another private art school, the Académie Colarossi at 10, rue de la Grande Chaumière. Situated in the Latin Quarter, a famed students' district, the school was in close proximity to the Sorbonne and the École des Beaux-Arts, while inexpensive cafés and lodgings for the students as well as artists' studios were spreading to the school's neighbourhood. Like the Académie Julian, the school attracted foreign students as well as unconventional French students such as Paul Gauguin (1848–1903) in the mid-1870s, who aspired to switch his career from stock-broking to painting, as well as Camille Claudel (1864–1943) in the early 1880s, who pursued sculpture, still a rare field for a woman at the time. The tutors in Mucha's time included Raphaël Collin (1850–1916), who was known for a hybrid painting style combining academic subjects with the luminous effects of light and atmosphere '*en plein air*'. Collin was then forging a strong bond with Japan and his style was particularly influential on the Japanese artists studying in Paris, the future founders of a new genre of 'Yōga' (Western-style paintings) in Japan. While Collin's taste for Japanese arts was shared by many contemporary artists under the vogue of Japonisme, it is conceivable that it was these Franco-Japanese ties at the Académie Colarossi that contributed to Mucha's interest in Japanese art objects, which he began to collect along with other Oriental and exotic bric-a-brac during the early 1890s (see p. 14).

Unfortunately, however, Mucha's formal art training was abruptly terminated in early 1889. Count Eduard Khuen-Belasi, Mucha's sponsor for the past seven years, had decided to discontinue his financial support to his prodigy for unknown reasons. The news was a blow (although later the Count explained this move as a 'medicine' to help Mucha's artistic development). Now the 28-year-old Mucha had to endeavour to stand on his own feet to earn his living.

Initial financial hardship was eased by Mucha's natural drawing skills and his long-standing experience as an illustrator. While he continued to produce illustrations for Filip Kuber's magazines, Mucha also began to send his drawings to publishing houses in both Prague and Paris. Thanks to the flourishing publishing industry in both cities, opportunities for illustration jobs for young artists were becoming more plentiful. Mucha's works began to appear in popular art and literature magazines such as *Světozor* in Prague and *La Vie Populaire* in Paris. Many of his fellow illustrators were not interested in imparting individual artistic quality to their original drawings or paintings, which, in their view, would be 'deformed' through the hands of engravers or lithographers for print-

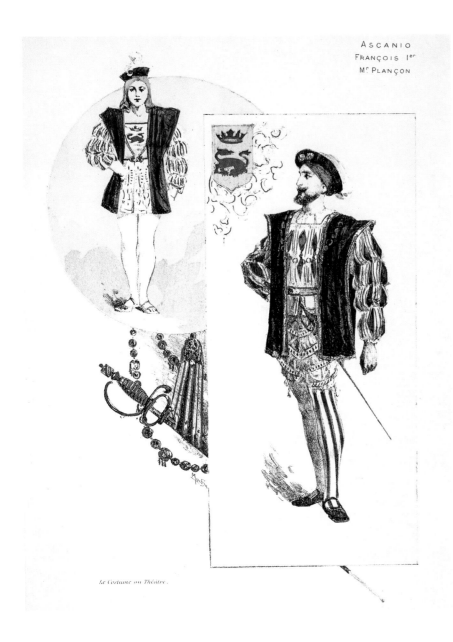

ASCANIO
FRANÇOIS Ier
Mr PLANÇON

Le Costume au Théâtre.

"I prefer to be someone who makes pictures for people, rather than who creates art for art's sake."

— ALPHONSE MUCHA

Costumes for the Opera *Ascanio*, 1890
Illustrations for *Le Costume au Théâtre*
Published by the Librairie Centrale des
Beaux-Arts

ing, but Mucha took his illustrations seriously. He approached his assignments in the same manner as for fine-art works by carrying out thorough research on the subjects and making numerous sketches from life as well as studies in varied media. Explaining the reason behind his method, he wrote: "[After leaving the Académie Colarossi] I found myself in the embarrassing predicament of someone with an incomplete education. I had to work in order to live and, at the same time, I had to continue my studies. I regarded every commission as a study from life."

Gradually Mucha acquired a reputation as a conscientious, reliable illustrator among Parisian editors and publishers. One of the first to spot his flair was Henri Bourrelier, the editor of *Le Petit Français Illustré* published by Armand Colin, a well-known educational publishing house. *Le Petit Français Illustré* was a new weekly youth magazine, featuring serialised illustrated stories, which needed fresh talent. Mucha became the magazine's regular illustrator, which led him to another commission from Armand Colin around 1891. This was a major

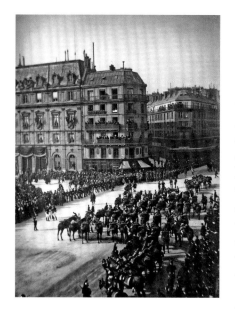

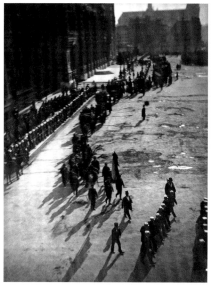

Funeral procession of the French President, Marie François Sadi Carnot, Paris, July 1, 1894 (from a series of nine views)
Photographs from original glass-plate negatives

Documenting the funeral procession, Mucha used a succession of images to capture the movement of the crowd and the rows of soldiers and dignitaries, very similar to today's news-film footage. These photographs also demonstrate Mucha's interest in the abstract patterns made by the figures as seen from a high vantage point.

project to illustrate a book by Charles Seignobos (1854–1942), *Scènes et Épisodes de l'Histoire d'Allemagne*, in collaboration with Georges Rochegrosse (1859–1938). Seignobos was then a rising Sorbonne scholar and Rochegrosse was one of the most popular Salon painters. For Mucha this meant the first professional acknowledgement of his art, which would now stand alongside the works of established artists such as Rochegrosse. As a patriotic Czech, however, Mucha was initially faced with a dilemma about gaining public recognition through a publication concerning the history of the German people and civilisation, which also encompassed conflicts with the Slavs and his own homeland. Despite this, and helped by Seignobos's clear and unbiased narrative, Mucha began to appreciate the contribution of German culture, which was worthy of respect, and he decided to illustrate key moments when the Czechs also played a significant rôle which impacted on the subsequent history of Europe as a whole. For this book (completed in 1897; published in 1898), Mucha eventually produced 33 illustrations (p. 16) whilst Rochegrosse contributed seven. This experience was to prove useful later when Mucha was conceptualising the *Slav Epic* project.

During this period, Mucha was also given helping hands from the Slav community. Władysław Ślewiński (1856–1918), a Polish painter and friend from the Académie Colarossi, introduced Mucha to Madame Charlotte Caron's (1849–1925) Crèmerie at 13, rue de la Grande Chaumière. This was a famous haunt for struggling artists, where the maternal Madame Charlotte served them nourishing meals for little money or often simply in exchange for artworks, as well as giving a sympathetic ear and advice. Ślewiński also found a little room for Mucha above the Crèmerie, and thus he became a member of this 'international bohemian society' formed largely of Slavs, Scandinavians and the French. Another artist called Kadár brought Mucha the illustration job for *Le Costume au Théâtre* (p. 17), which gave Mucha the opportunity to collaborate with Kadár as well as the Montmartre-based Swiss graphic artist Théophile Steinlen (1859–1923).

With his growing reputation as an illustrator, Mucha's financial circumstances were improving too. He happily spent his first payments from his publishers on a harmonium, which revived his musical activities in the community. By 1893, he had also purchased his first camera, a 4x5-inch format using glass-plate negatives, which he used to take photographs of himself as well as his friends striking theatrical poses for his illustrations. From this time onwards, self-portrait, often in the Russian shirt symbolising Slavic unity (p. 92), became one of the recurring themes in Mucha's works, especially photographs. Moreover, the use of photography for composing scenes (*mise-en-scène*) became Mucha's regular method for interpreting narratives and for developing the characters to be depicted in his work.

Among Mucha's friends photographed during this period was Gauguin, who had met Mucha in early 1891 at Madame Charlotte's before his first trip to Tahiti. In the summer of 1893, when Gauguin returned to Paris, he and Mucha renewed their friendship. Mucha was then living in a larger room with a studio across the road at No. 8 and he invited the penniless Gauguin to share his studio for a while. Several surviving photographs include an informal portrait of Gauguin seated at Mucha's harmonium, half-dressed (p. 93 left), as well as a *mise-en-scène* with Gauguin posing for Mucha's illustration for a scene in Judith Gautier's (1845–1917) novel, *Mémoires d'un Éléphant Blanc*, which was serialised in *Le Petit Français Illustré* between September 1893 and January 1894 (see p. 19).

In the summer of 1894, Mucha's endeavours paid off with unexpected artistic recognition. Four of his paintings, produced as studies for the illustrations for

Scènes et Épisodes de l'Histoire d'Allemagne (p. 16), were exhibited at the Paris Salon which opened in May and he received an Honourable Mention. Mucha's modest success was celebrated by the whole community at Madame Charlotte's. The joyous occasion was, however, followed by the shocking news that shook the entire French nation: the assassination of Marie François Sadi Carnot (1837–1894), President of France, who was fatally stabbed by a 20-year-old Italian anarchist in Lyon on June 24. The incident had been preceded by a series of anarchist bombings in Paris over the previous few years, in protest against social injustices suffered by the under-class, thus revealing the other side of Belle Époque prosperity. Clearly affected by this violent event, Mucha documented Carnot's state funeral on July 1 in a series of photographs (p. 18), capturing from a high vantage point the movement of the funeral procession, "an unprecedented spectacle" according to a London newspaper.

In the late autumn of 1894, Mucha met August Strindberg (1849–1912), a friend of Gauguin's and a new arrival at Madame Charlotte's bohemian colony. He was living in a boarding house at No. 12, where he was to stay until February 1896. It was during this period that the Swedish writer was going through the 'Inferno Crisis' known from the title of his autobiographical novel, *Inferno* (1897). In his spiritual struggles, Strindberg was powerfully drawn to mysticism and occultism, the branches of Theosophy that pursued spiritual truth beneath the visible, material world. Promoted chiefly by Madame Blavatsky's (1831–1891) highly influential Theosophical Society, such spiritualist pursuits were spreading among European thinkers, paranormal scientists and artists during the late 19th century. Like his friends in Paris such as Gauguin, Sérusier and the Nabis, Mucha was also drawn to spiritualist thinking, and soon became Strindberg's regular companion for philosophical discussions. Through this friendship, Mucha was profoundly influenced by Strindberg's notion of the 'mysterious forces' that would guide a man's life. This was later to contribute to Mucha's own idea of 'unseen powers', which is manifested in his work as the recurring motif of a mysterious figure appearing behind the subject.

At the turn of the year 1894–1895, while he was exploring the spiritual world with Strindberg, Mucha was also going through the greatest turning point in his life. It was then that Sarah Bernhardt (1844–1923), the actress called 'the Divine', was to step into his life and become the catalyst for this change.

LE DIRECTEUR DU GRAND CIRQUE DES DEUX MONDES.

TOP
Illustration for *Mémoires d'un Éléphant Blanc* by Judith Gautier, 1894
Published by Armand Colin & Cie, Paris

ABOVE
Paul Gauguin posing for Mucha's illustration for *Mémoires d'un Éléphant Blanc*, 1893
Photograph from original glass-plate negative

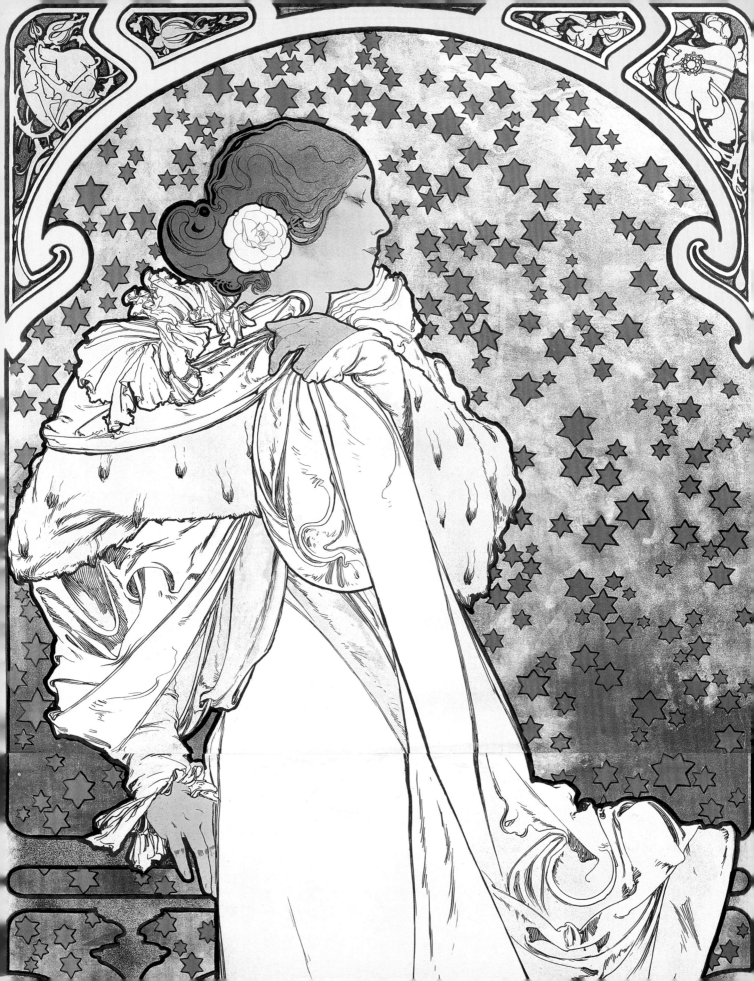

The Divine Sarah and Art Nouveau

Sarah Bernhardt was the first superstar long before the notion was created by Hollywood's star-making system. Not only was she a gifted performer on stage in the classic sense, but she also had the charisma to charm the masses. In the age of developing mass-media culture, she intuitively knew the most effective means for making her appeal known to the public. She was one of the earliest show-business personalities to exploit photography and modern printing technology in order to reach a wider audience. Moreover, she lent her name to commercial products, and created the famous myth of 'sleeping in her coffin' by provoking the public imagination with a photograph of her in this pose. Consequently, she attracted a level of public attention unprecedented for her time, making her probably the most visible actress in the world.

Mucha began to work for this superstar actress towards the end of 1894 with a poster advertising the new production of the play *Gismonda* to be staged from January 4, 1895 at the Théâtre de la Renaissance (pp. 23, 25). Bernhardt had bought this theatre herself in 1893, when she was the actor-director-producer there. The original production of the play was premièred on October 31, 1894 but it was then withdrawn before Christmas. Presumably, there was a poster made for the première but none has survived. What is certain is that the Divine Sarah was dissatisfied with the existing design, and the play was revived in the New Year with a new poster by Mucha.

According to Mucha's own account, the story began with a telephone call from Bernhardt to Maurice de Brunhoff (1861–1937), the manager of the printing firm of Lemercier, on St. Stephen's Day (December 26). Bernhardt requested a new poster for *Gismonda*, which she insisted would be ready for New Year's Day. Unfortunately, it was the middle of the holiday period; none of the regular artists at Lemercier were available except for Mucha, who happened to be there, correcting proofs on behalf of his friend Kadár. With little time and no choices, de Brunhoff turned to Mucha in desperation and it was thus that Mucha was offered the job despite his lack of experience in this field. However, this account seems to exaggerate the 'fate' factor, stemming from Mucha's mystic tendency. Considering Mucha's good reputation as a draughtsman at the time and his substantial familiarity with the subject, de Brunhoff's decision was perfectly reasonable. Indeed, in November of 1894, Mucha had been despatched by Lemercier to watch *Gismonda* in order to depict "the most noteworthy

Sarah Bernhardt: study of full-standing figure, c. 1896
Pen and ink on paper, 41.5 x 26 cm / 16⅜ x 10¼ in.

OPPOSITE
La Dame aux Camélias (detail), 1896
Colour lithograph, 207.3 x 76.2 cm / 81⅝ x 30 in.

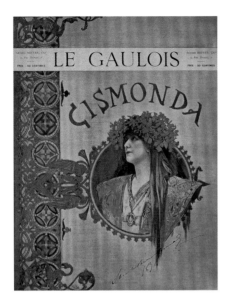

Le Gaulois, 1894
Special Christmas supplement
dedicated to *Gismonda*
Illustrated magazine published in 1894
Lithograph, 35 x 27 cm / 13¾ x 10⅝ in.

OPPOSITE
Gismonda (detail), 1894
Colour lithograph, 216 x 74.2 cm /
85 x 29¼ in.

scenes" from the play for the Special Christmas Supplement of the Parisian newspaper, *Le Gaulois* (left). For this assignment he produced numerous watercolours and drawings, which were praised by the newspaper for their "exquisite graphic beauty". With this experience, Mucha must have been the most knowledgeable artist about the play at Lemercier.

It is clear that Mucha benefited from his knowledge of the play when producing the poster, and in the limited time available the large stock of sketches and drawings for *Le Gaulois* proved indispensable. Mucha was able to select the most memorable scene – Gismonda's Palm Sunday procession – as the basis for his characterisation of Sarah Bernhardt in the rôle. Technical factors influenced the design too since Mucha's preferred choice of a vertical format to show the actress's full standing figure did not fit the proportions of the standard lithographic stone. As an economical solution, the image was printed in two parts on a single stone, with top and bottom side by side; the printed sheet was cut into two sections, which were then joined together, resulting in the unusually long format. Furthermore, and probably because of the limited time, Mucha had to simplify the background, leaving it blank except for the Byzantine mosaic tiles behind Gismonda's head, rather than filling in the entire area with ornamental details, as was the case in his preliminary sketch. As a result, however, Mucha's image became closer to Bernhardt's own aesthetics: "The most important factors on stage are us, the actors. This sort of junk [excessive stage props] is a distraction to the audience's attention."

Yet Mucha's endeavour paid off. Bernhardt was thoroughly satisfied with his design and the finished poster for *Gismonda* appeared on the hoardings of Paris on January 1, 1895, causing a great sensation. Mucha was at the time primarily known as a book illustrator but he soon became the most talked-about poster artist in the French capital.

Paris was also then entering a golden age of posters. Thanks to the advancement of colour lithography and increasing demands for advertising in Belle Époque consumerism, the artistic quality of posters saw considerable improvements. With such recent examples as those by Jules Chéret (1836–1932), Eugène Grasset (1845–1917) and Toulouse-Lautrec (1864–1901), posters were now becoming a new form of visual art beyond their primary function as tools for advertising; they were thus also worthy of critical attention and were becoming collectible objects. Mucha wrote later about the poster culture in *fin-de-siècle* Paris that "posters were a good way of enlightening the wider public. They would stop and see the posters on their way to work, deriving spiritual pleasure from them. The streets became open-air art exhibitions."

Mucha's *Gismonda* sent a breath of fresh air through these "open-air art exhibitions" owing to its striking design, which featured the following: the impressive life-size figure of the Divine Sarah presented in a distinctive format; the mystical and exotic effects created by the Byzantine mosaic motifs as well as her orchid head-dress and a palm branch; and flowing outlines rendered by exquisite draughtsmanship and the tastefully restrained colours in contrast to the much brighter hues common in contemporary Parisian posters. Altogether, these elements gave a measure of dignity – a quality not usually expected from posters – to Mucha's work. According to the Czech painter Ludvík Kuba (1863–1956), who was then amongst the crowd admiring Mucha's poster, its delicate pastel colours and the decorative effect of the Byzantine motifs were so powerful that the impact was a "revelation". Delighted by her 'discovery' of a new talent, Bernhardt offered Mucha a contract to produce more work for her and her

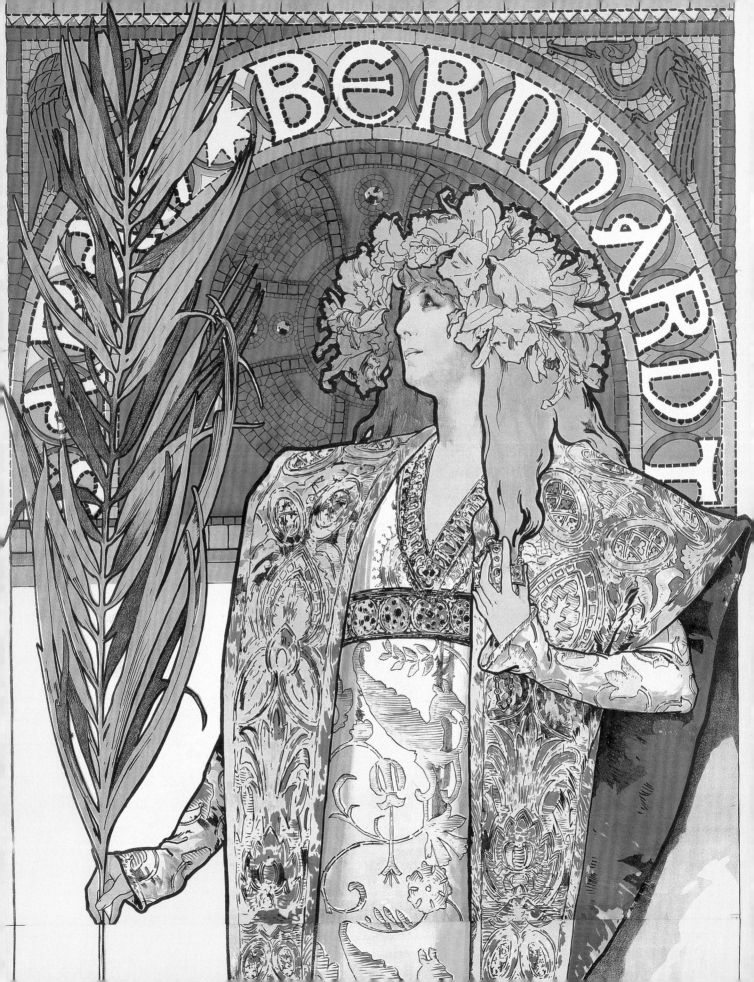

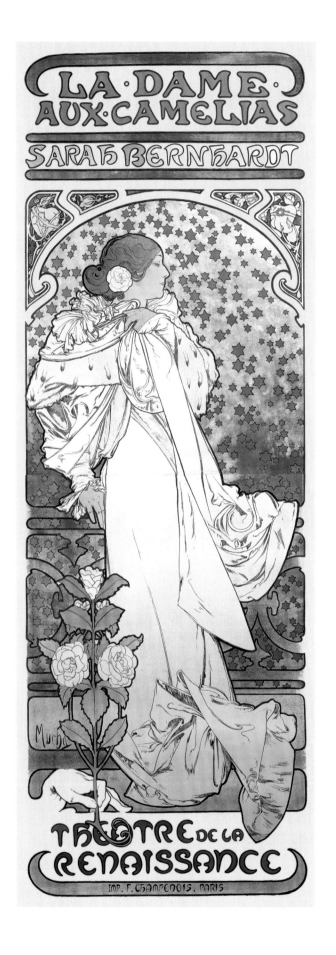

La Dame aux Camélias, 1896
Colour lithograph, 207.3 x 76.2 cm /
81⅝ x 30 in.

La Dame aux Camélias was originally written as
a novel by Alexandre Dumas, fils (1824–1895),
and subsequently adapted for the stage in 1852.
This poster was prepared for Bernhardt's new
production of the play, which was premièred on
September 30, 1896. Presenting the tragic hero-
ine Camille as a modern Parisian woman in a
chic dress designed by Mucha, the poster not
only renewed the old-fashioned image of the
play but also influenced contemporary fashion.

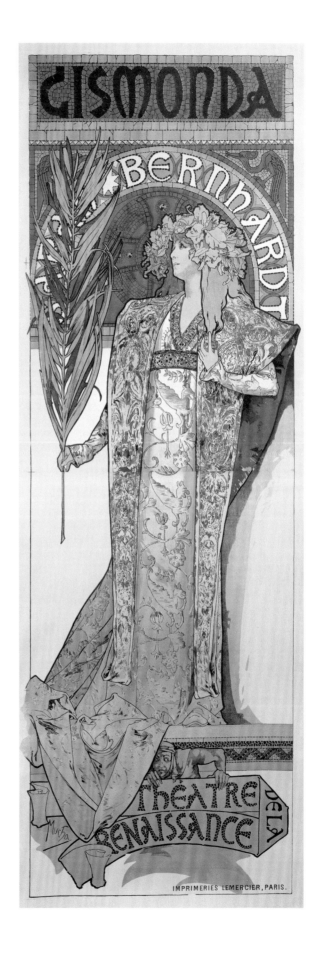

Gismonda, 1894
Colour lithograph, 216 x 74.2 cm /
85 x 29¼ in.

Mucha portrayed Bernhardt as an exotic Byzan-
tine noblewoman wearing a splendid gown and
an orchid head-dress with a palm branch in her
hand. This costume was worn in the last act, the
climax of the play, when she joined the Palm
Sunday procession. Placing her life-size figure
on an arched platform, Mucha rendered the
beauty and dignity of her personality on stage
rather than representing her realistic features or
the story.

Head of Sarah Bernhardt, 1896
Study for *Lorenzaccio*
Pencil on paper, 25 x 21.5 cm / 9⅞ x 8½ in.

*"She [Sarah Bernhardt] had
expressiveness and classical nobility ...
and then there was the particular
magic of her movements ... Every
feature of her face, every movement
of her clothing, was profoundly
conditioned by her spiritual need."*

— ALPHONSE MUCHA

theatre, designing posters, stage sets, costumes and jewellery, as well as serving as general artistic advisor. Under this contract, which ran from 1895 until 1900, Mucha designed six further posters for Bernhardt productions: *La Dame aux Camélias* (pp. 20, 24), *Lorenzaccio* (p. 27), *La Samaritaine* (p. 29), *Médée* (p. 31), *La Tosca* (1899) and *Hamlet* (p. 30). In designing these posters Mucha applied the same stylistic formula developed from *Gismonda*: the tall narrow format (the ratio of height to width being approximately 3:1) featuring the single figure of the actress standing and posing in the costume most appropriately representing the character in each play, which is placed on a platform, domed or with a halo, just like the devotional images familiar to Mucha from his childhood.

The collaboration between Bernhardt and Mucha proved to be mutually beneficial. With his consistent design principle and the repeated representation of Bernhardt as an idol, Mucha's posters created an enduring iconic image (see p. 28) which enhanced her status as an international superstar. From 1896 onwards, Bernhardt used Mucha's poster designs to publicise all her American tours. As for Mucha, the association with Bernhardt affected every aspect of his life from finance and social contacts to exposure to the public eye and media attention. Furthermore, Bernhardt became his muse, mentor and life-long friend, and through this friendship Mucha grew as an artist. By closely observing every movement of this world-class actress both on stage and during rehearsals, he was able to gain deeper insights into theatrical expressions. He later wrote on his impressions of the actress: "Every feature of her face, every movement of her clothing, was profoundly conditioned by her spiritual need." He also noted "the particular magic of her movements", described as "a spiral principle" by the contemporary composer Reynaldo Hahn (1874–1947), as the flowing movement of her standing, turning or sitting made the train of her dress curl around her. Over the next few years, such details began to manifest themselves in his posters of the graceful female figure, often combined with a swirling tail of cloth or tendrils surrounding her body.

The success of *Gismonda* and his new status as Bernhardt's prodigy brought Mucha a flood of commissions from a variety of publishers and printers. Among them, the Parisian printer F. Champenois was the quickest to make a move, realising the great commercial possibilities in Mucha's work. Mucha was offered a generous monthly salary, in return for giving Champenois the right to reproduce all his designs. In 1896, Mucha signed an exclusive contract with the printer, and, thanks to his improved financial position, he was able to move to a beautiful house at 6, rue du Val-de-Grâce, originally built by the famous Baroque architect François Mansart (1598–1666), where he rented a three-bedroom apartment and a studio with large windows.

Champenois made Mucha busy with commissions for advertising posters, including ones for famous brands such as JOB (cigarette papers; p. 6), Ruinart (champagne), Lefèvre-Utile (biscuits; p. 46), Nestlé (baby food), Moët & Chandon (champagne; p. 43), Waverley (American bicycles) and Perfecta (English bicycles; p. 47). In addition, Mucha and Champenois embarked upon a new enterprise altogether – decorative panels (*panneaux décoratifs*). These were posters primarily without text, designed purely for decorative purposes. Produced in large quantities, these panels were also available to the wider public, becoming an alternative form of art, which could be displayed in ordinary households.

The first of Mucha's decorative panels was *The Seasons*, published in 1896 as a set of four posters featuring single figures of women personifying the four

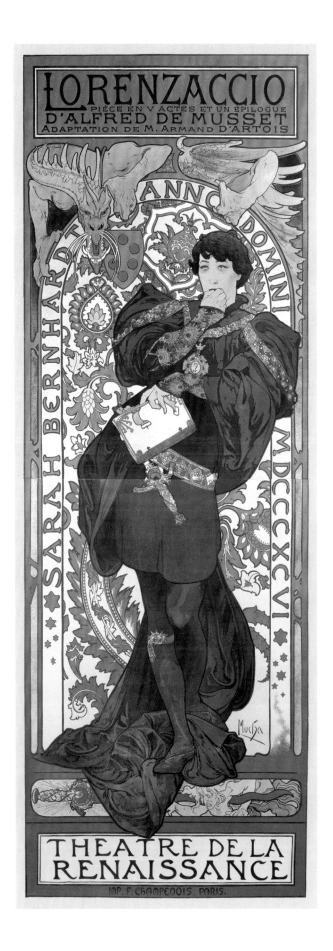

Lorenzaccio, 1896
Colour lithograph, 203.7 x 76 cm /
80¼ x 30 in.

Premièred on December 3, 1896, *Lorenzaccio*
was a revival of the play written by Alfred de
Musset (1810–1857) in 1834, set in 16th-century
Florence. Bernhardt played the male role,
Lorenzaccio (or Lorenzo) de' Medici, who
assassinates Alessandro de' Medici, the tyrant
duke of Florence and his cousin. While pre-
senting Lorenzaccio as a dashing young man,
whose elegantly S-curved figure is silhouetted
against the arched window, Mucha focused at
the same time on Bernhardt's facial expression
to portray the hero's contemplation of murder.

OPPOSITE

Sarah Bernhardt as Mélissinde, 1897
Art edition of poster for *La Plume* magazine
Colour lithograph, 69 x 51 cm /
27⅛ x 20⅛ in.

In portraying Bernhardt as Mélissinde in the
play *La Princesse lointaine* by Edmond Rostand
(1868–1918), Mucha's design was originally
produced for the poster for the banquet held on
December 9, 1896 in honour of the leading lady,
as well as to announce the forthcoming article
about her in *La Plume*. Its success prompted
Champenois to recycle the design for a collec-
tors' edition poster without the text, as seen
here, and for a postcard.

La Samaritaine, 1897
Colour lithograph, 173 x 58.3 cm / 68⅛ x 23 in.

Premièred on April 14, 1897, the play drew on a
theme from a Biblical episode about Photina,
the Samaritan woman (John 4:1–30). The poster
shows Bernhardt as Photina with a large water
jar, which alludes to her encounter with Jesus at
the well and her conversion to become one of
his followers. Behind her head is a halo decor-
ated with Hebrew letters (reading 'Jehovah') and
the words 'Sarah Bernhardt' in the style of
Hebrew script, which heightens the atmosphere
of the play.

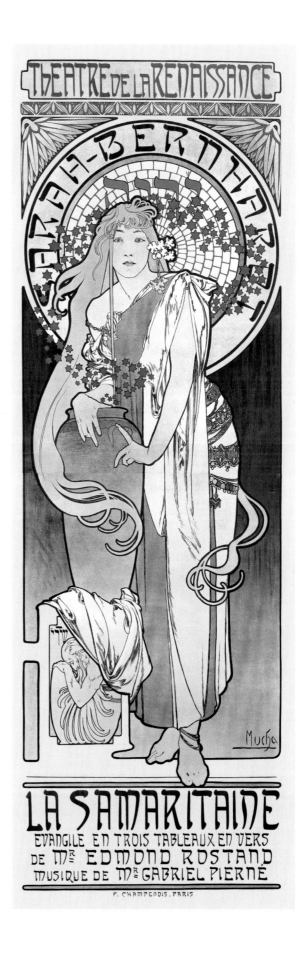

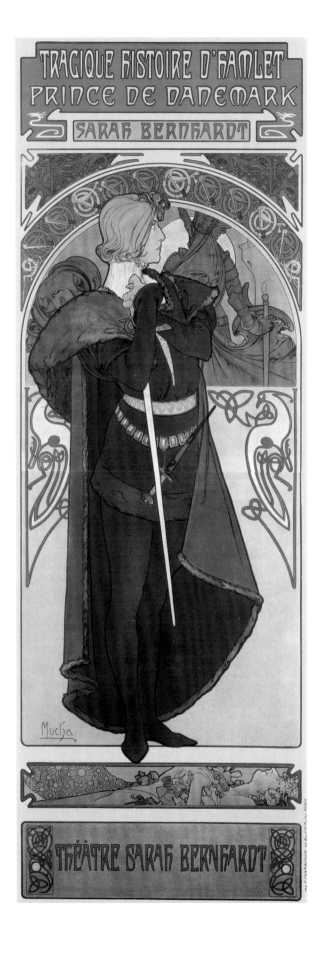

Hamlet, 1899
Colour lithograph, 207.5 x 76.5 cm /
81¾ x 30⅛ in.

This French adaptation of Shakespeare's *Hamlet*
was premièred in May 1899, starring Sarah
Bernhardt in the title role. Mucha's poster
presents the solitary figure of Hamlet against an
arched background richly decorated with Celtic
motifs. As exemplified in the cartoon, Mucha
prepared many of his designs with well-defined
outlines and at a scale of 1:1 in relation to the
ultimate sizes of the posters, which enabled the
draughtsmen and lithographers to reproduce
the designs faithfully during production.

BELOW
Cartoon for the poster of *Hamlet*, 1899
Charcoal on tracing paper, 201 x 77.2 cm /
79⅛ x 30⅜ in.

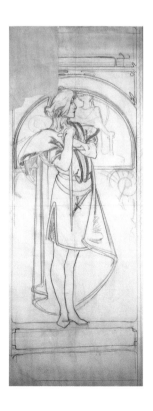

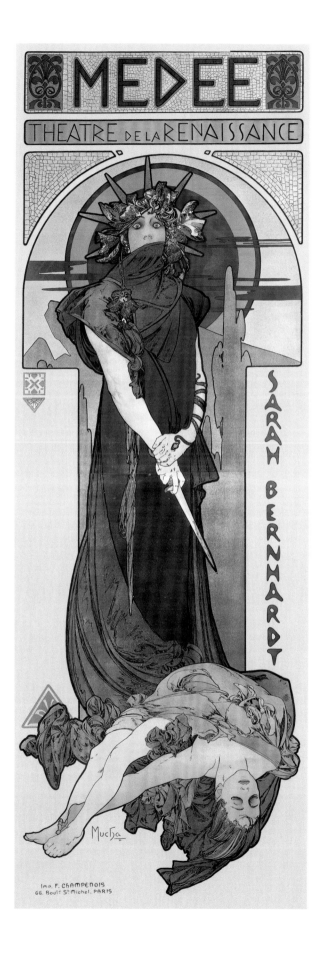

Médée, 1898
Colour lithograph, 206 x 76 cm / 81⅛ x 30 in.

Based on the Greek classic by Euripides
(*c.* 480–406 BC), this adaptation of the play by
Catulle Mendès (1841–1909) was written in 1898
especially for Sarah Bernhardt to portray the
tragic heroine, who killed her two children by
her husband Jason after he had betrayed and
left them. The production was premièred on
October 28, 1898. Mucha's poster captured the
essence of the tragedy in the frozen figure of
Médée, staring out and stiffly holding the
bloodstained dagger in an extreme state of
shock.

Amants, 1895
Colour lithograph, 106.5 x 137 cm / 42 x 54 in.

Mucha's first theatrical poster after signing the
contract with Sarah Bernhardt was for a comedy
by Maurice Donnay, premièred on November 5,
1895 but without Bernhardt herself. Unlike
Mucha's designs for the great actress, this wide-
format poster is packed with numerous figures.
The composition is divided into three scenes: a
Punch and Judy show in the top left, a tragedy
in the top right and a party scene dominating
the lower part, where three figures of fashion-
able women offer a harmonious rhythm to the
overall composition.

PAGE 34
Chocolat Idéal, 1897
Colour lithograph, 117 x 78 cm /
46 x 30¾ in.

PAGE 35
Bières de la Meuse, 1897
Colour lithograph, 154.5 x 104.5 cm /
60⅞ x 41⅛ in.

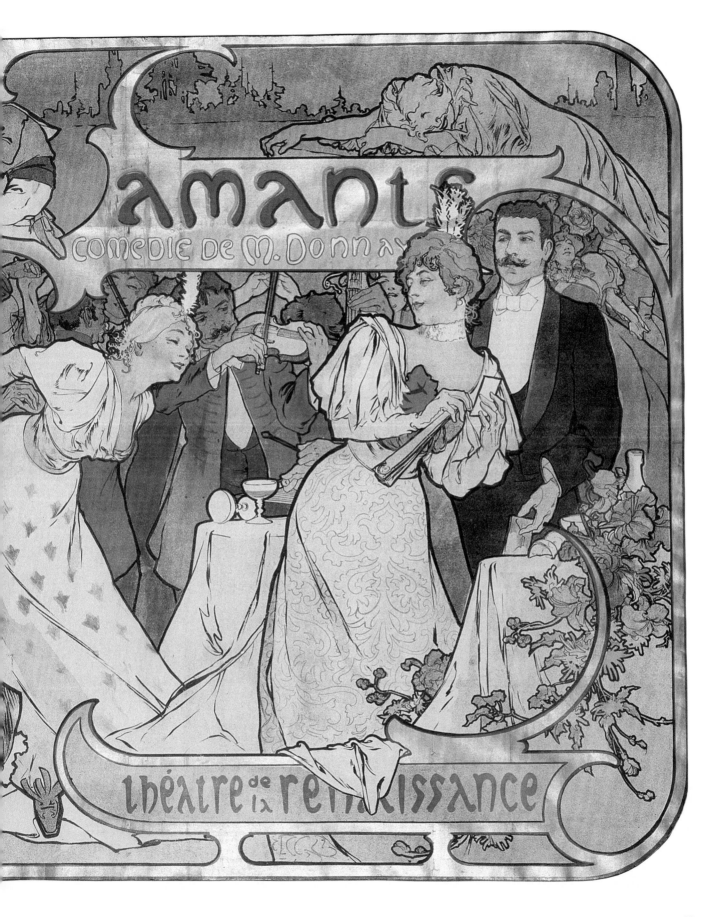

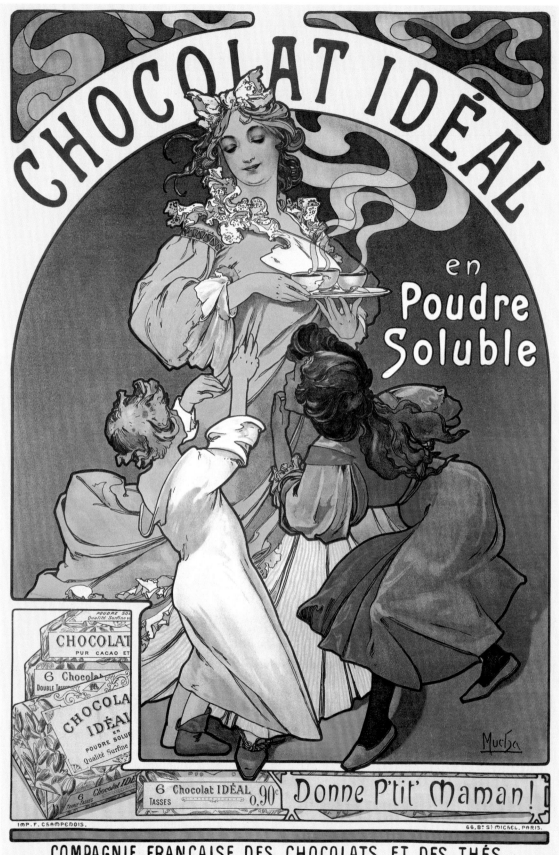

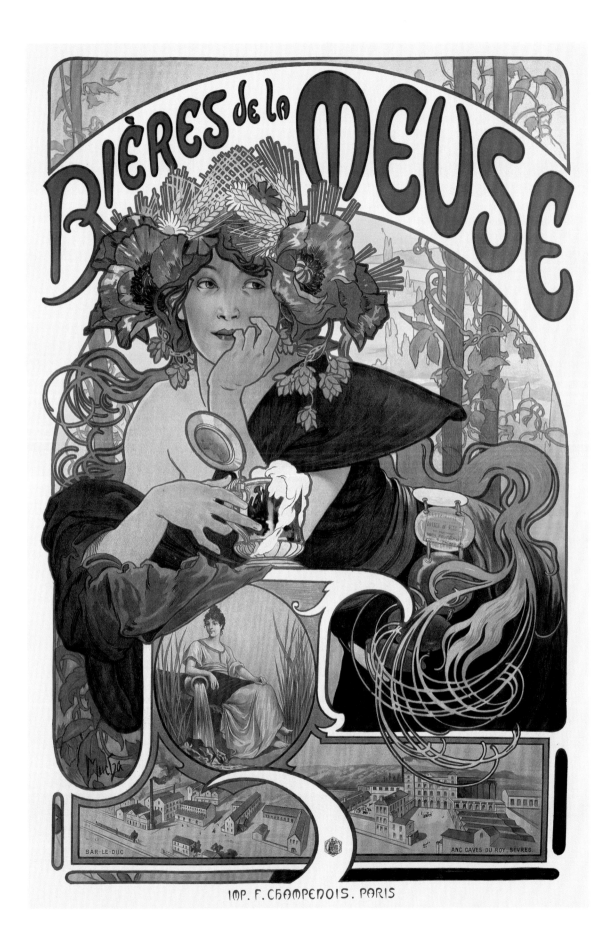

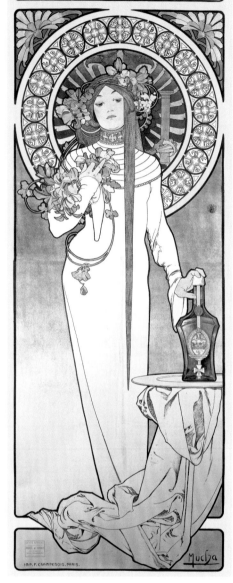

La Trappistine, 1897
Colour lithograph, 206 x 77 cm / 81⅛ x 30¼ in.

PAGES 38–39
The Seasons, 1896
Colour lithograph, 54 x 103 cm /
21¼ x 40½ in.

Here depicting a popular and classic theme, Mucha personified the seasons as nymph-like women in a series of four panels. Each one captures the mood of the season – innocent Spring, sultry Summer, fruitful Autumn and frosty Winter – against a corresponding seasonal landscape; as a whole together they represent the harmonious cycle of nature. The great success of this series led to many variants, including this design incorporating all four panels into a single ornamental frame.

PAGE 40
The Byzantine Heads: Brunette, 1897
Colour lithograph, 34.5 x 28 cm / 13⅝ x 11 in.

PAGE 41
The Byzantine Heads: Blonde, 1897
Colour lithograph, 34.5 x 28 cm / 13⅝ x 11 in.

The pair of decorative panels presented here show the profiles of two women with luxurious hair ornaments set in circular frames in the style of Byzantine portraits. The exquisite pattern surrounding the circular frames simulates lacework, a decorative element familiar in Moravian craftwork.

OPPOSITE
Zodiac, 1896
Colour lithograph, 65.7 x 48.2 cm /
25⅞ x 19 in.

One of Mucha's most popular posters, *Zodiac* features the striking profile of a majestic woman, whose regal bearing is emphasised by elaborate jewellery. The twelve signs of the zodiac are incorporated in the circular motif in the back-ground. This design was originally made as a company calendar for Champenois but its distri-bution rights were bought by *La Plume*'s editor Léon Deschamps to sell as a calendar and a deco-rative panel under the name of his magazine.

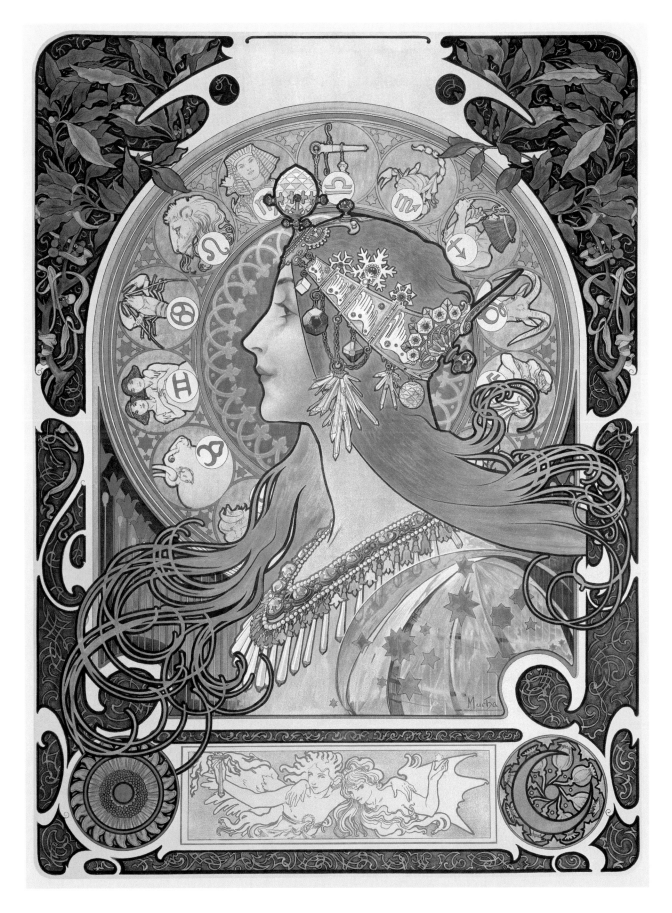

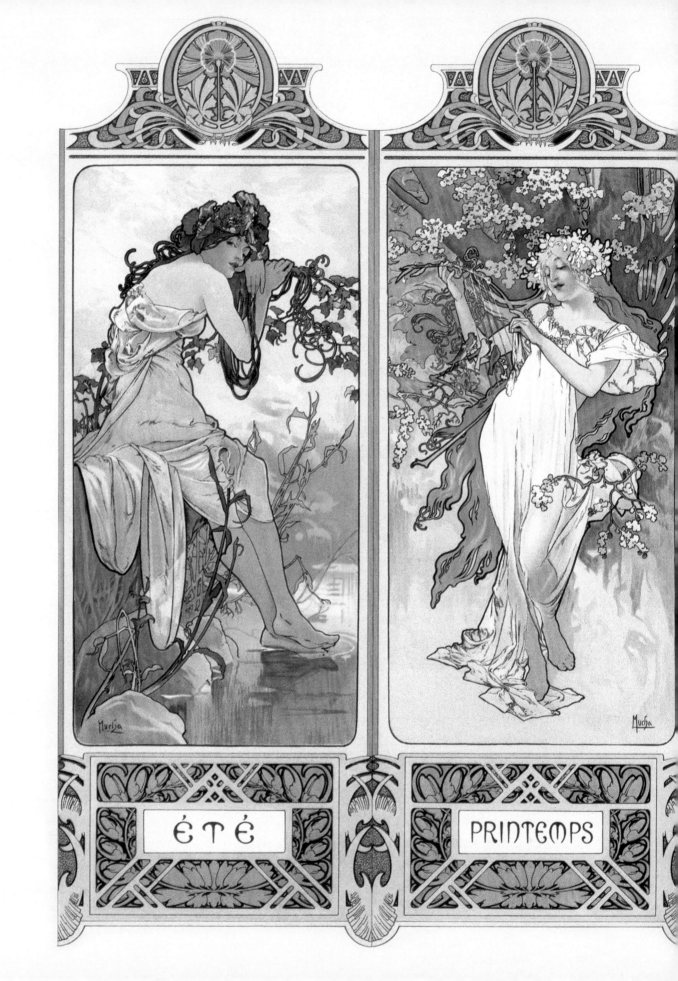

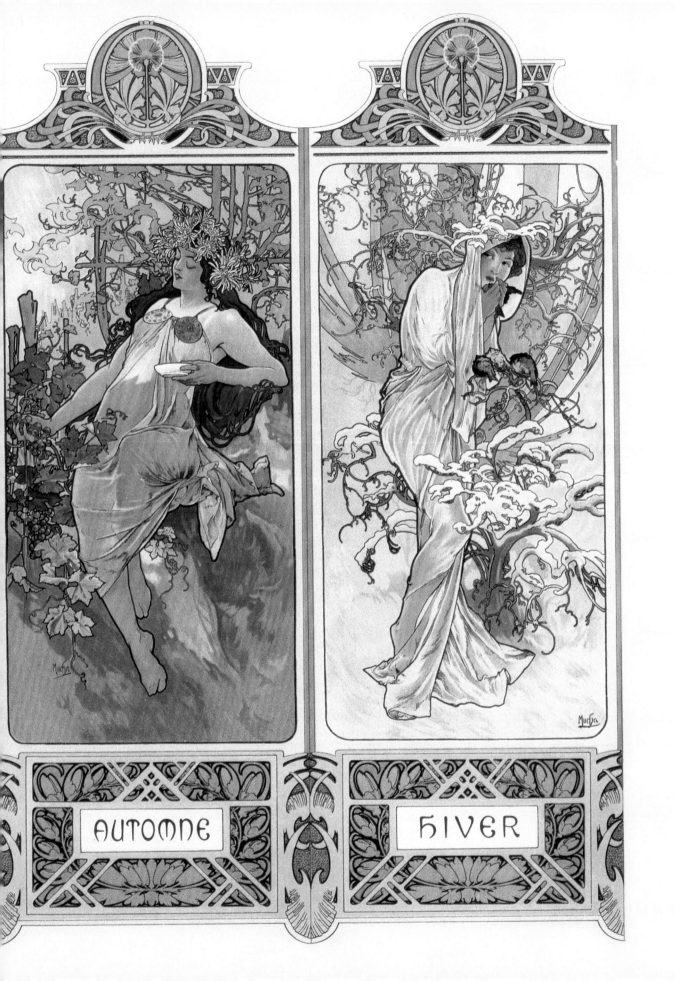

AUTOMNE

HIVER

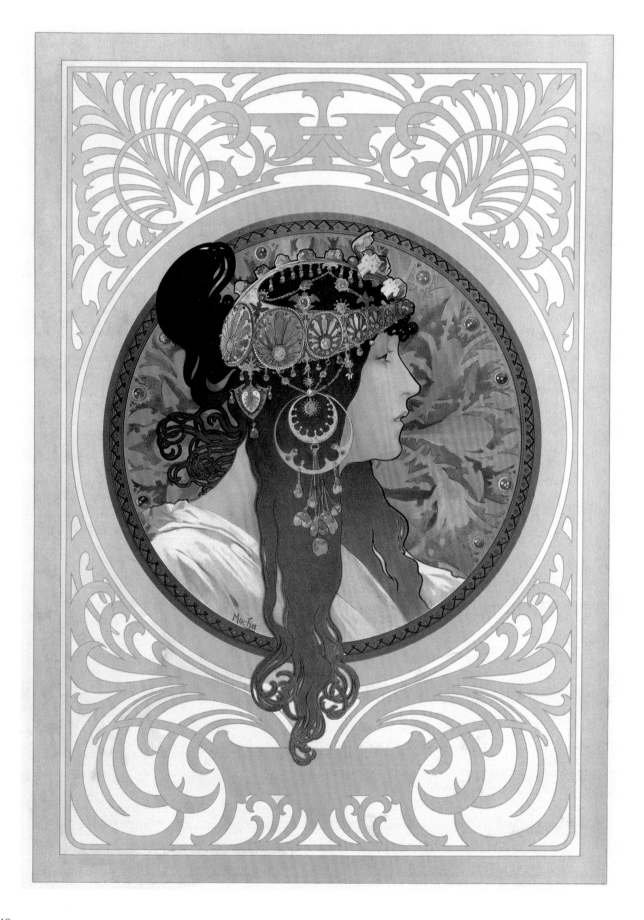

MONACO·MONTE-CARLO

Affiches Artistiques de la Société "LA PLUME"
31, Rue Bonaparte, PARIS.

Imp. F. CHAMPENOIS.
66, Boul! S! Michel, PARIS.

42

seasons (pp. 38–39). This series proved to be so popular that the same subject was represented in new designs made in 1897 and 1900. *The Seasons* was followed by other popular series such as *The Flowers* (pp. 44–45), *The Arts* (1898), *The Times of the Day* (1899), *Precious Stones* (1900) and *The Moon and the Stars* (1902). Mucha also designed decorative panels as pairs or as singles, for example, *The Byzantine Heads* (pp. 40, 41) and *Rêverie* (p. 4) respectively.

Between 1896 and 1904 Mucha produced well over 100 poster designs for Champenois. Many of them were reproduced in different editions (e.g. on vellum, Japanese paper and satin for the more affluent collectors) and formats (e.g. smaller sizes, as a single sheet incorporating all panels in an ornamental frame), as well as being reformatted as calendars and postcards. It was this large body of graphic output that established Mucha's fame as a leading exponent of Art Nouveau, the international decorative style spreading across Europe and the United States by 1900.

However, Mucha's view of art stands in some contrast with his widely recognised rôle as an Art Nouveau artist. According to his son and biographer Jiří Mucha (1915–1991), Mucha was quite indifferent to the Art Nouveau movement and the work of his contemporaries: "What is it, new art (*art nouveau*)? … Art can never be new," Mucha would say when asked about it. To him, art was eternal and had nothing to do with "passing fashions"; in this respect he was also critical of the trend of "art for art's sake", which was, in his view, primarily concerned with the pursuit of "new" styles, ignoring the content – the artist's message. Nevertheless, Mucha's rise as a major artist was without question closely entwined with the development of the Parisian art scene in the second half of the 1890s.

In the same year as Mucha's emergence as a poster artist in 1895, German-born art dealer Siegfried Bing (1838–1905) opened a gallery in Paris called L'Art Nouveau. Having pioneered the introduction of Japanese art to the West in the 1870s, Bing was a leading advocate of Japonisme. With this new enterprise, he aspired to present new paths to contemporary art and design, bringing together the arts of East and West and breaking down the boundary between fine and decorative arts. He promoted works by artists who shared his vision, including Henry van de Velde (1863–1957), Louis Comfort Tiffany (1848–1933), Émile Gallé (1846–1904), René Lalique (1860–1945), Georges de Feure (1868–1943) and the Nabis.

With the success of Bing's business, his gallery became an influential centre of the new artistic style, putting the term 'Art Nouveau' into circulation and giving the name to the new trend. Although Mucha never worked with Bing, he was friendly with Bing's associates, and, considering his stylistic affinity with these artists (e.g. whiplash curves, bold outlines and decorative motifs taken from flowers and plants), it is readily conceivable that in the public's mind, Mucha was associated with this 'Art Nouveau' school.

The emerging Art Nouveau style succeeded in reaching a wider audience through reproductions that appeared in art magazines, which were becoming more numerous and in which graphic arts began to take centre stage. Founded by the poet and novelist Léon Deschamps (1864–1899) in 1889, *La Plume* was particularly well known for its support for graphic arts, with one issue in 1893 dedicated to the history of the poster. In 1894 Deschamps opened an exhibition space, Salon des Cent, within the magazine's publishing premises in order to showcase works by those artists associated with *La Plume*, including Chéret, Grasset, Toulouse-Lautrec, de Feure, the Nabis and Paul Berthon (1872–1909), many of whom overlapped with Bing's circle.

Monaco • Monte-Carlo, 1897
Colour lithograph, 108 x 74.5 cm / 42½ x 29⅜ in.

Moët & Chandon: Champagne White Star, 1899
Colour lithograph, 60 x 20 cm / 23⅝ x 7⅞ in.

In this design, the aroma of champagne is symbolised by the figure of a beautiful woman holding a plate of grapes, intertwined with flowers and swirling vine tendrils.

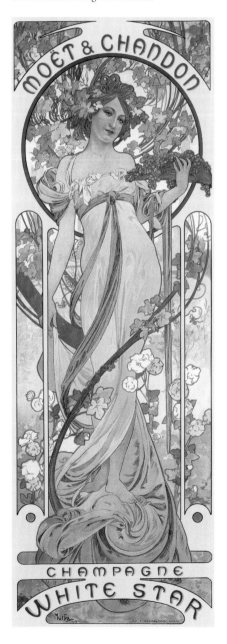

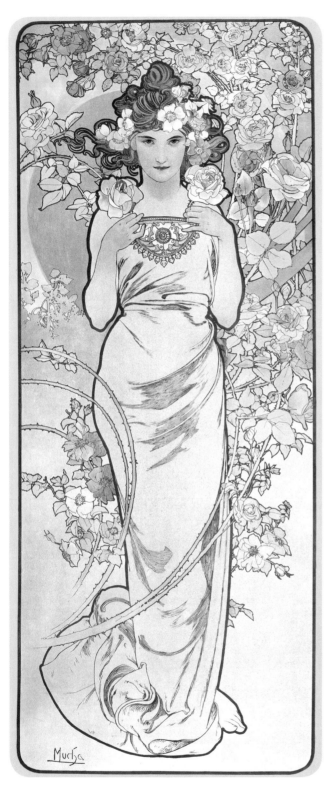

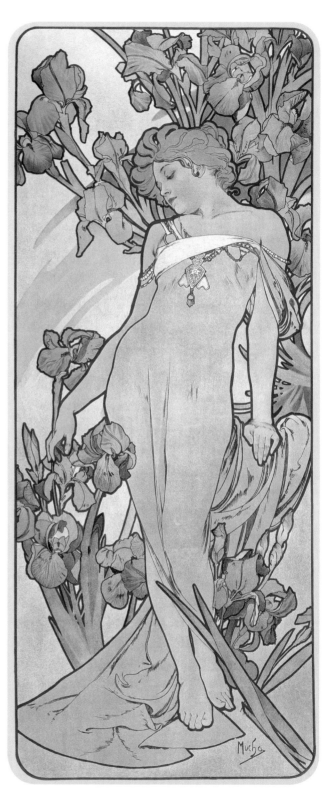

The Flowers: Rose, 1898
Colour lithograph, 103.5 x 43.3 cm / 40¾ x 17 in.

The Flowers: Iris, 1898
Colour lithograph, 103.5 x 43.3 cm / 40¾ x 17 in.

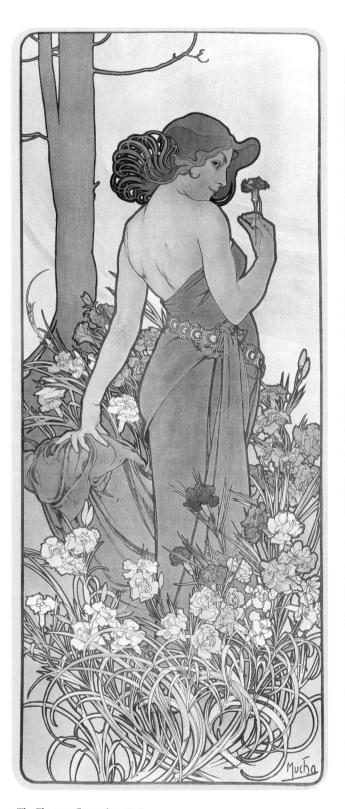

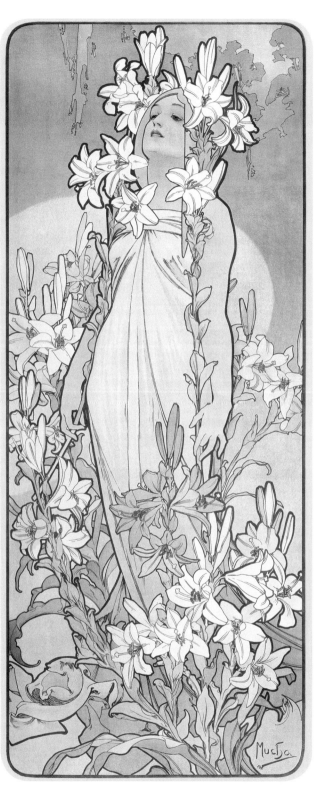

The Flowers: Carnation, 1898
Colour lithograph, 103.5 x 43.3 cm / 40¾ x 17 in.

The Flowers: Lily, 1898
Colour lithograph, 103.5 x 43.3 cm / 40¾ x 17 in.

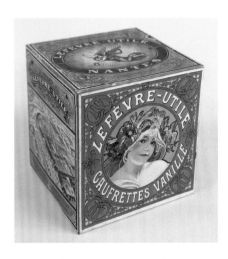

Box for Lefèvre-Utile biscuits: Gaufrettes
Vanille, *c.* 1900
Tin box with colour-lithographed label,
19.3 x 18.3 x 17.5 cm / 7⅝ x 7¼ x 6⅞ in.

OPPOSITE
Cycles Perfecta, 1902
Colour lithograph, 53 x 35 cm / 20⅞ x 13⅞ in.

Having been invited by Deschamps, Mucha joined the Salon des Cent in 1896, and the following year he was given a major retrospective there (p. 48), showing a staggering 448 works. Concurrently, *La Plume* published a special issue devoted to Mucha, which served as the exhibition catalogue. The cover was designed by the artist himself and his design was used for many subsequent issues of the magazine. Furthermore, *La Plume* organised a travelling exhibition from this retrospective, which went on to Vienna, Prague, Munich, Brussels, London and New York, promoting Mucha internationally. This heightened visibility led to more exhibitions, publications and publicity, as well as the application of his designs to packaging and popular decorative objects. Looking back at *fin-de-siècle* Paris, Mucha wrote later: "My art, if I may call it that, crystallised. It was *en vogue*. Under the name of '*le style Mucha*' it spread to factories and workshops." He was now one of the most copied artists across the globe and his style became the hallmark of the era.

The great popularity of the Mucha style was supported by its instant recognisability and the allure of the 'Mucha Woman'. Seductive, inspirational, wholesome or comforting, her image forms the central part of Mucha's design. She is a realistic yet otherworldly beauty, unlike the crudely stylised features seen in the majority of contemporary posters. Her pose is flowing, often adorned with the arabesques of her long hair and sumptuous floral motifs, accompanied by other decorative details alluding to the theme, and thus she acts as a messenger to communicate the idea – i. e. the attractiveness of the products or the aesthetic pleasure of poetry and harmony found in nature – to the viewer. For his distinctive decorative scheme, Mucha synthesised a variety of ornamental motifs – Japanese, Rococo, Gothic, Celtic, Greek and Islamic – from his design reference books, including the seminal work by Owen Jones (1809–1874) from 1856, *The Grammar of Ornament* (the French edition was published in 1865).

On the whole, however, Mucha's style evolved organically from his Moravian and Slavic roots. In 1894 he employed Byzantine motifs for *Gismonda* mainly because of the play's Greek setting, but from 1896 onwards he integrated, regardless of the subject, traditional elements from his homeland into his designs, which manifest themselves as floral and other botanical motifs inspired by Moravian folk arts and crafts; as prominent discs evoking Byzantine icons (in Mucha's view Byzantine art was the home of Slavic civilisation); and also the curves and geometric patterns familiar in Czech Baroque churches. During his groundbreaking retrospective at the Salon des Cent in 1897, Mucha, distressed by press speculations about his exotic origins, turned to Sarah Bernhardt for help. Her statement appeared in *La France*, affirming that Monsieur Mucha was "a Czech from Moravia not only by birth and origin, but also by feeling, by conviction and by patriotism". To Mucha, his Czech identity far outweighed fame.

PAGES 44–45
The Flowers, 1898
In this series Mucha personified four flowers, attributing their visual impressions to different types of women as well as evoking the symbolic meaning of each from the traditional 'language of flowers'. Furthermore, in blending the women and the floral motifs together Mucha enhanced the decorative effect of the female figures, which was to be explored further in both *Documents décoratifs* (see pp. 62, 63) and *Figures décoratives*.

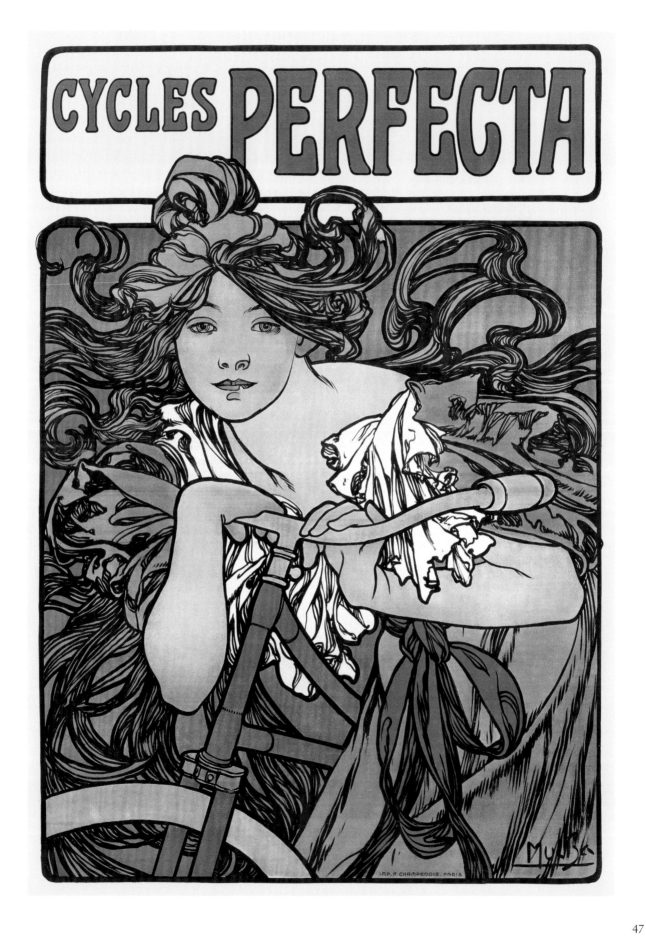

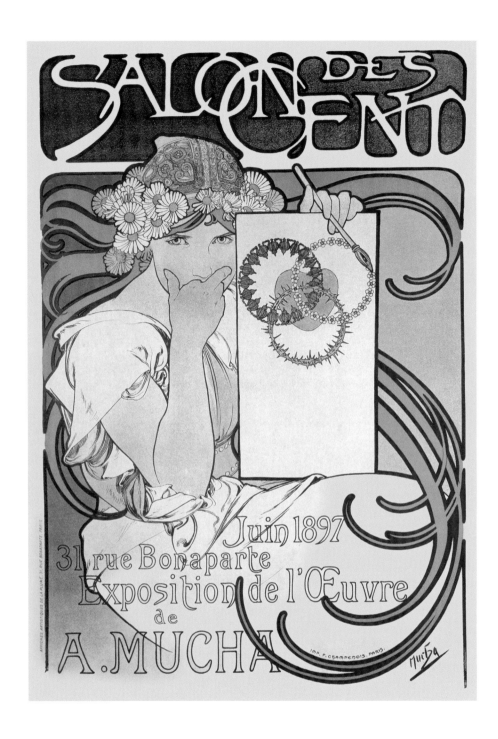

Salon des Cent Exhibition of the Work
of A. Mucha, 1897
Colour lithograph, 66.2 x 46 cm / 26 x 18⅛ in.

In the course of designing this exhibition poster Mucha incorporated various Moravian elements into his decorative motifs, such as the embroi-dered folk cap worn by the girl and her daisy crown which evokes the meadows of his home-land. Additionally, the girl holds a pen and a picture which shows a heart in the middle of three intersecting garlands, composed of thorns, flowers and fruit, alluding to the fate of Mucha's homeland.

OPPOSITE:
Salon des Cent 20th Exhibition, 1896
Colour lithograph, 63 x 43 cm / 24¾ x 16⅞ in.

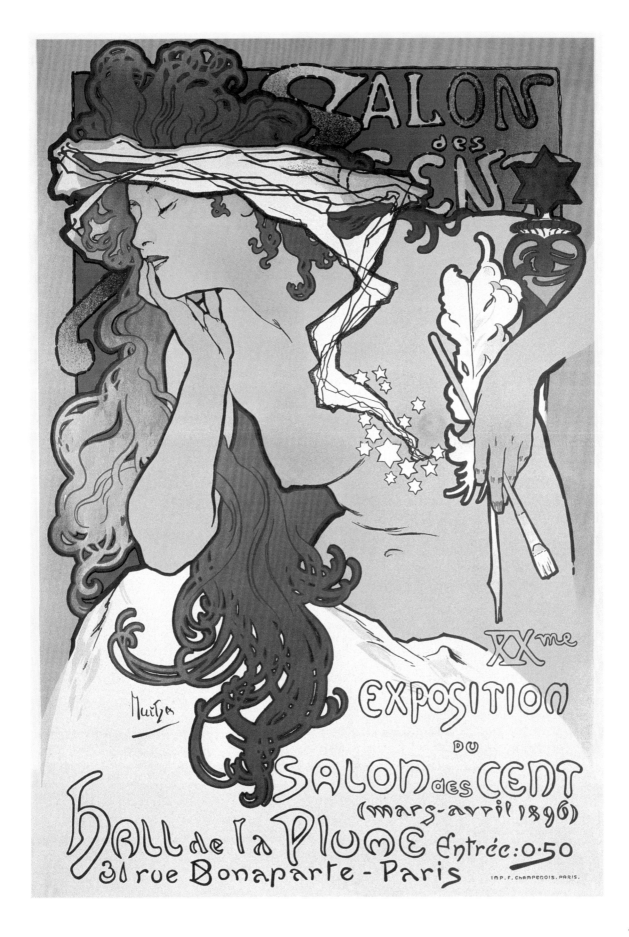

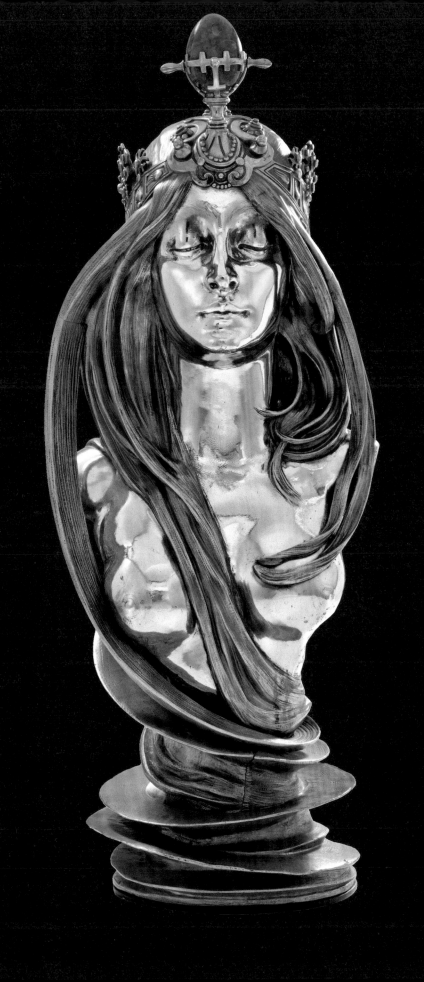

Triumph in Paris, Sorrows of Bosnia

"It was midnight, and there I was all alone in my studio in the rue du Val-de-Grâce among my pictures, posters and panels. I became very excited. I saw my work adorning the salons of the highest society … I saw the books full of legendary scenes, floral garlands and drawings glorifying the beauty and tenderness of women. This was what my time, my precious time, was being spent on, when my nation was left to quench its thirst on ditch-water. And in my soul I saw myself sinfully misappropriating what belonged to my people." Thus did Mucha describe retrospectively in a letter to a friend his situation at the turn of 1899–1900. At the time he was reaching a new peak in his career with the approaching Paris Exposition Universelle of 1900 (April 15–November 12), which brought in numerous projects including commissions from the Austro-Hungarian Empire and important French manufacturers, as well as invitations to the various exhibitions. However, within Mucha the gap between his worldly success in the French capital and his patriotic aspirations – to serve his homeland with his art – was increasing. Furthermore, his artistic ambition was shifting to a grander vision under the influence of Freemasonry. A fraternal organisation, which he had joined in 1898, the society worked for the betterment of humanity through charitable works, human solidarity and the quest for higher intellectual, moral and spiritual values.

According to Mucha's account of his Masonic life published in *Stavba* (Prague, 1932), despite his early upbringing under Catholic teachings, which prohibited Freemasonry as a heresy, he had been drawn to it since the 1880s as a result of the influence of his former patron Count Eduard Khuen-Belasi who viewed its membership as "a great honour". In Paris, while exploring his spiritualist ideals, Mucha continued to be intrigued by this organisation. Then, in 1897, after meeting a Masonic businessman called Pierre Béziaux, Mucha decided to join the Freemasons. With Béziaux's help he was eventually accepted as an apprentice of Les Inséparables du Progrès, a lodge of the Grand Orient de France in Paris, on January 25, 1898. Originally founded in 1728 as the Première Grande Loge de France, the Grand Orient was the oldest and most significant Masonic order in Continental Europe. Its large membership included many influential politicians and thinkers along with an increasing number of middle-class members. In maintaining the spirit of the French Revolution – Liberty, Equality, Fraternity – as their motto, they were also an

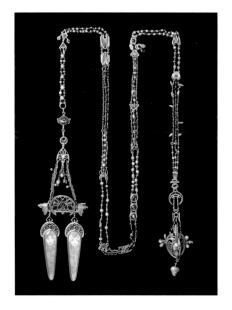

Ornamental Chain with Pendants, 1900
Gold, enamel, fresh-water pearls, mother of pearl and semi-precious stones, (length) 159 cm / 62⅝ in.
Manufactured by Georges Fouquet, Paris, after Mucha's design

Designed by Mucha for Georges Fouquet, this ornamental chain was exhibited on the jeweller's stand at the Paris Exposition. A variety of gems was employed in the synthesis of decorative elements from Eastern and Western art, with Mucha thereby demonstrating his innovative approach to jewellery design.

OPPOSITE
Nature, c. 1900
Bronze, silvering and crocidolite cat's eye, 70.7 x 28 x 27.5 cm / 27⅞ x 11 x 10⅞ in.
Karlsruhe, Badisches Landesmuseum

ABOVE
Seventh allegorical page of Le Pater, 1899
*'And lead us not into temptation, but deliver
us from evil'*
Photogravure, 40.4 x 30.2 cm / 15⅞ x 11⅞ in.

OPPOSITE
Le Pater, 1899
Title-page for the illustrated book,
41 x 31 cm / 16⅛ x 12¼ in.
Published by H. Piazza et Cie, Paris

The title-page of *Le Pater* demonstrates the harmonious union of Mucha's inherent Symbolist tendency with Masonic symbolism. While the composition is dominated by an allegorical figure rendered in '*le style Mucha*', the vertical band towards the spine of the book carries the seven ornamental motifs associated with Freemasonry as well as other mystic symbols. These motifs re-appear in the subsequent pages of the book, serving as a guide to the symbolic meaning of each verse.

"LE PATER"

COMMENTAIRE ET COMPOSITIONS

DE

A. M. MUCHA

F. CHAMPENOIS
IMPRIMEUR-ÉDITEUR
66, Bᵈ S.-MICHEL, PARIS

H. PIAZZA & Cⁱᵉ
« L'ÉDITION D'ART »
4, RUE JACOB, PARIS

active political lobby, advocating 'progressive' concepts such as the separation of Church and State, and freedom of conscience. For Mucha, who was seeking "the power of brotherhood, the power of love and the power of enthusiasm", which would enable him to work for "the liberation and advancement of the Czech nation", Freemasonry provided the ideological framework for his philosophy as a thinking artist.

Mucha's Masonic philosophy is reflected in *Le Pater* (pp. 52, 53), the illustrated book of his personal interpretation of the Lord's Prayer – the most widely used Christian prayer. He conceived this work as a private project roughly at the same time as his initiation into Freemasonry, envisaging it to be a "means to spread light that would reach even into the remotest corners". Unlike the usual treatment of the subject, as exemplified by the contemporary illustration by James Tissot (1836–1902) for *The Life of Our Lord Jesus Christ*, published in 1896–1897, Mucha's *Le Pater* was not the depiction of an episode in the New Testament but the pictorial expression of his own philosophical idea inspired by the words of the prayer. Mucha divided the prayer into seven verses to analyse the idea behind the words and give a new insight into each line, each of which was represented in a set of three pages treated in different styles. The first, a heading page with one verse of the prayer presented in Latin and in French, was richly decorated with mystic symbols combined with floral and geometric patterns. The second, a textual page with Mucha's interpretation of the verse, was decorated in the style of an illuminated manuscript. The third, a full-page monochromatic drawing (p. 52), showed a visual interpretation of Mucha's text on the previous page.

As a whole, Mucha's *Le Pater* depicted the gradual progress of mankind in seven stages from the darkness of ignorance, through a long journey pursuing higher states of spirituality, guided by the Light, towards the Ideal to meet the Supreme Being. It was a total work of art in book form expressing his spiritual vision with words combined with diverse visual languages. Above all, by synthesising into a coherent decorative scheme a wide range of iconographic elements from different cultures and religions, such as Christianity, Islam and Judaism, as well as Egyptian and Masonic symbols, Mucha was able to express his notion of God as the universal spiritual force beyond any dogmatic differences between religions.

Le Pater was published in Paris on December 20, 1899 by F. Champenois and H. Piazza. Mucha regarded the book as his greatest achievement and in-

BELOW LEFT
Bosnia and Herzegovina Pavilion at the Paris Exposition Universelle of 1900: interior view with Mucha's mural
Reproduction of a vintage print

BELOW RIGHT
Bosnian people in ceremonial costume – from Mucha's research trip to the Balkans, 1899
Photograph from original glass-plate negative

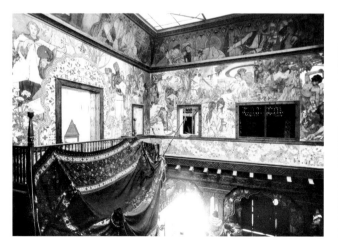

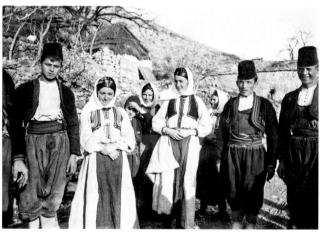

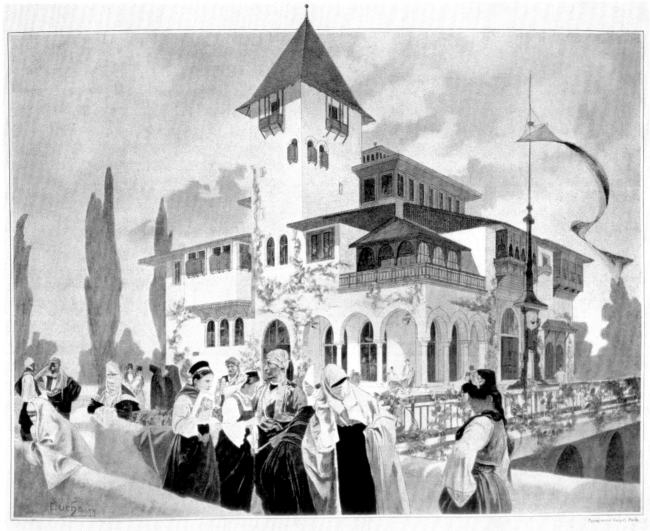

LE PAVILLON DE BOSNIE ET D'HERZEGOVINE A L'EXPOSITION UNIVERSELLE DE 1900
AQUARELLE DE MUCHA (A.D.)

cluded it among his exhibits at the Paris Exposition Universelle of 1900. In the May 1900 issue of *Le Mois Littéraire et Pittoresque*, the critic Abel Fabre (1872–1929) wrote that Mucha's "artistic treatment of the prayer goes beyond the concepts that we are accustomed to in Christian iconography. God is no longer the old man with a white beard as embodied by our ancestors. Instead, he is a vast and powerful being whose immense shadow permeates everything."

In the spring of 1899, while *Le Pater* was being prepared, the Austro-Hungarian government approached Mucha, now seen as a leading 'Austro-Hungarian' artist, with a major commission for the forthcoming Paris Exposition – the decoration of the Bosnia and Herzegovina Pavilion, which was to be built between the Austrian Pavilion and the Hungarian Pavilion. At the time, Bosnia and Herzegovina was an Ottoman province, but since 1878 it had been a *de facto* colonial territory of the Austro-Hungarian Empire. Over the previous 20 years, the Austrian administration had been increasing its influence in the region, controlling the local resentment as well as tensions

Bosnia and Herzegovina Pavilion, 1900
Mucha's drawing reproduced in *Le Figaro illustré* (March 1, 1900)

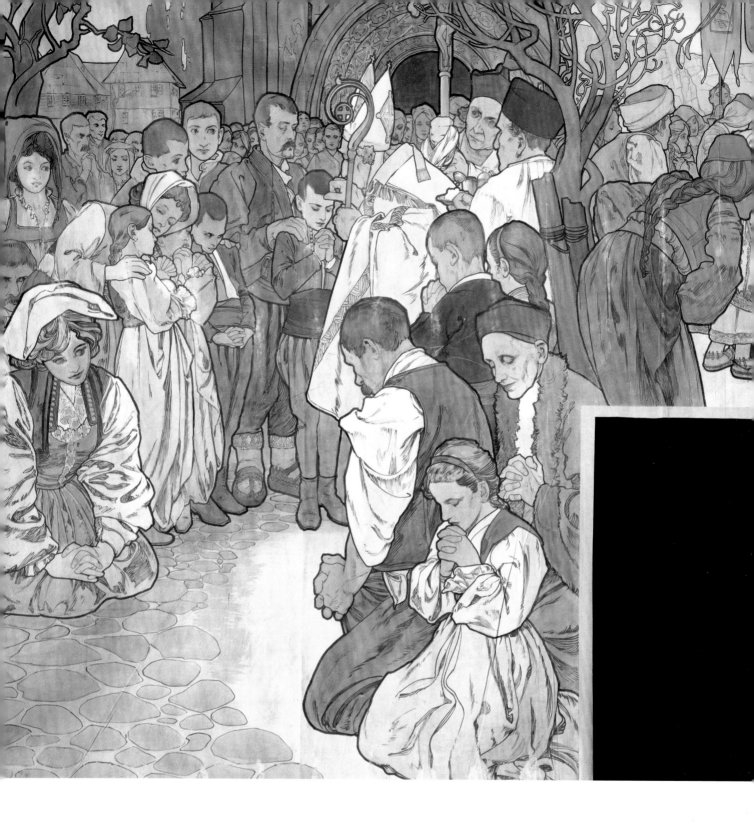

56

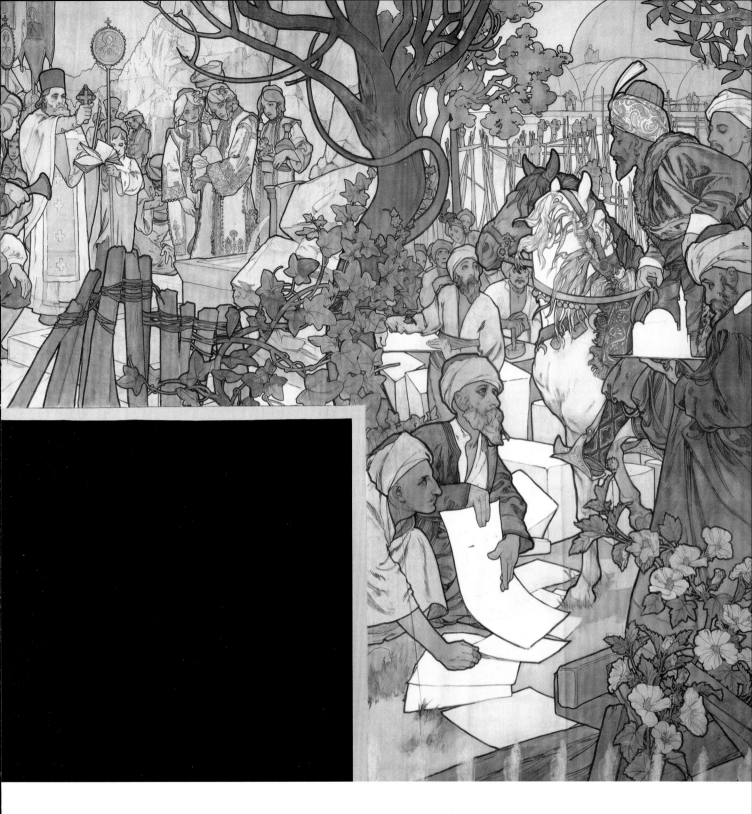

***The Catholic Faith, the Orthodox Faith
and Islam***, 1900
Mural for the Bosnia and Herzegovina Pavilion
Tempera and watercolour on canvas,
344 x 687 cm / 135 x 270 in.
Prague, Museum of Decorative Arts

The three scenes here representing the different
religious faiths are integrated harmoniously into
one continuous landscape. The Catholic faith is
depicted on the left with a bishop administering
confirmation to the Bosnian people. In the
centre, an Orthodox monk performs the rite

of the Great Blessing of Water. Islam is repre-
sented by a new mosque, which is being built in
the background, while in the foreground an
architect is instructing the builders.

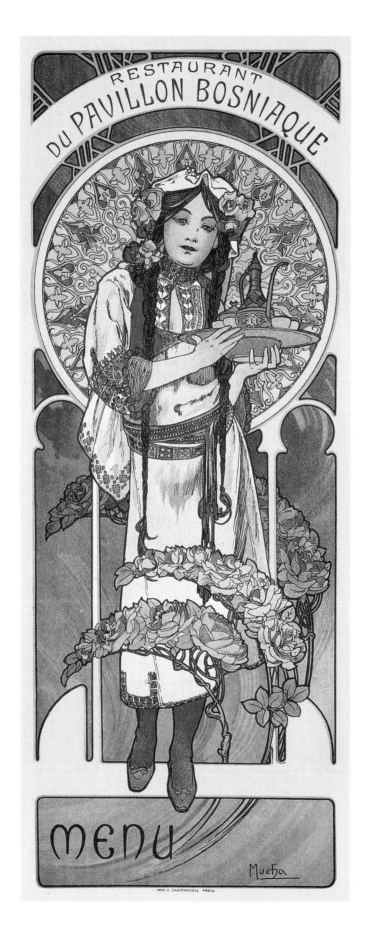

OPPOSITE
Austria at the World Exhibition:
Paris 1900, 1900
Colour lithograph, 98.5 x 68 cm /
38¾ x 26¾ in.

In the design-work for this poster, Mucha was
responsible only for the left-hand section and
the lettering above the images of the six Austrian
buildings presented at the Paris Exposition
Universelle of 1900. Mucha's allegorical compo-
sition features two figures, with Austria personi-
fied as the woman at the front being unveiled by
Paris behind her, thus representing the theme of
the poster: "Paris presents Austria to the world".
The Empire's emblem, a double-headed eagle, is
integrated into the circular motif in the back-
ground.

LEFT
Restaurant du Pavillon Bosniaque:
Menu, 1900
Colour lithograph, 33 x 13 cm / 13 x 5⅛ in.

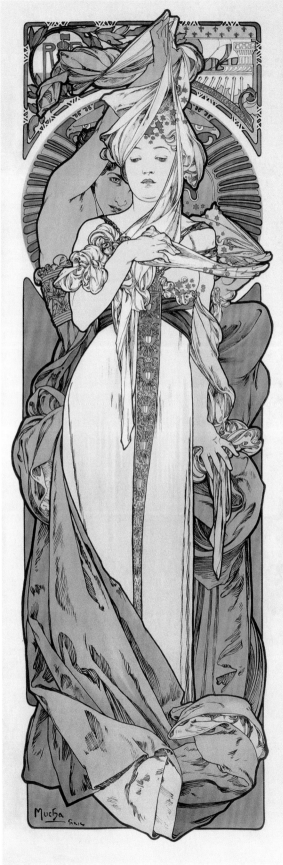

OESTERREICH
AVF DER
WELTAVSSTELLVNG
PARIS 1900

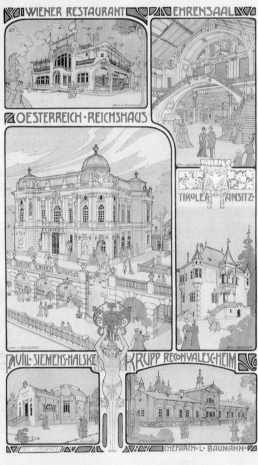

WIENER RESTAURANT

EHRENSAAL

OESTERREICH·REICHSHAUS

TIROLER ANSITZ

PAVILL·SIEMENS·HALSKE

KRUPP RECONVALESC·HEIM

CHEFARCH·L·BAUMANN·

KVNSTANSTALT F. CZETGER WIEN.

Boutique Fouquet: design for the interior –
fireplace, mirror and ceiling (detail), 1900
Pencil and watercolour on paper, 65 x 48.5 cm /
25⅝ x 19⅛ in.

In his designs for the interior of the Boutique
Fouquet Mucha conceived the space as a magic-
al 'backdrop' which would enhance the beauty
and spirit of the new jewellery. This drawing
shows a shell-shaped fireplace, built-in floral
light fittings, a group of two allegorical figures
with a clock as well as a circular mirror
surrounded by a decorative painting – all the
elements are united by curving lines and themes
from nature to form a harmonious whole.

Boutique Fouquet: reconstruction of the
interior designed by Mucha, at the Musée
Carnavalet, Paris

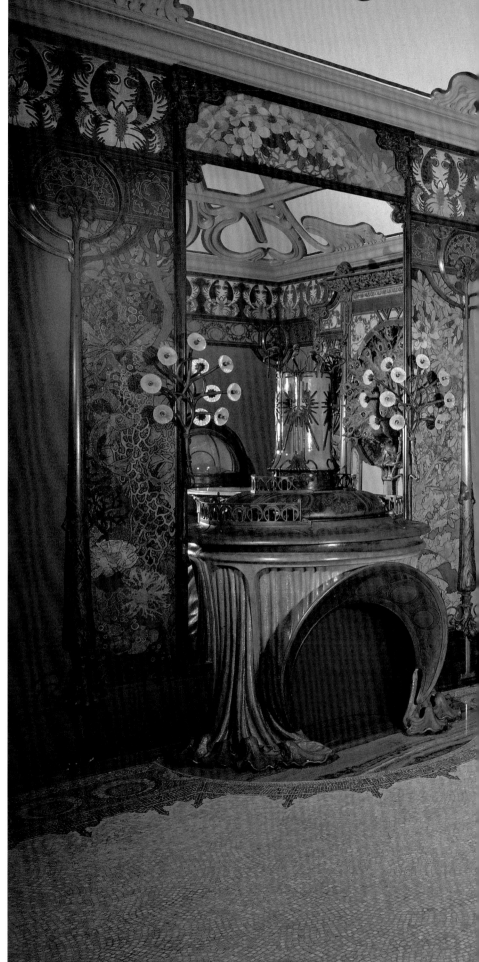

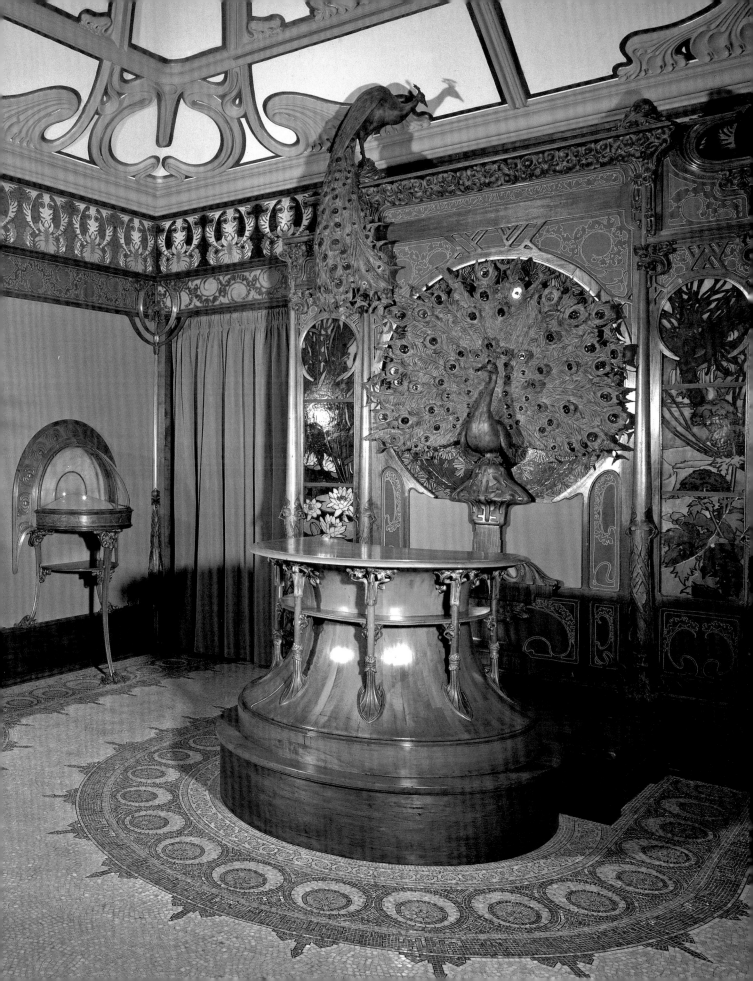

Documents décoratifs: drawing for Plate 59, *c*. 1901–1902
Pencil, ink and white highlights on paper, 48 x 31 cm / 18⅞ x 12¼ in.

Documents décoratifs showed not only examples of Mucha's 'ready-to-use' designs for a wide range of objects and daily utensils but also the process of stylisation used to transform a drawing from nature into a decorative pattern or the form of an object. For this publication Mucha prepared numerous drawings in varied styles and media that demonstrate his versatile draughtsmanship.

OPPOSITE
Documents décoratifs: Plate 29, 1902
Colour lithograph, 46 x 33 cm / 18⅛ x 13 in.
Published by the Librairie Centrale des Beaux-Arts, Paris

between its Muslim and Slavic communities. The Empire was now preparing for full-scale annexation, and so this Pavilion had special importance as a platform for demonstrating to the world its achievement of bringing peace, order and prosperity to the region.

The commission presented Mucha with a dilemma in that it would mean working for a project generated by the Empire's subjugation of the Slavic people. However, it was also a great opportunity for Mucha to work *for* his fellow Slavs: in view of their political predicament, he originally wanted to portray the suffering of the people who had been humiliated by foreign occupations for many years, but understandably this theme was not well received by the Austrian authorities, and Mucha was forced to change his concept to a more positive, celebratory one. Eventually, he resolved the problem by presenting an idealised vision of the civilisation of Bosnia and Herzegovina, whose indigenous culture had been enriched by foreign influences, developing into a multi-religious nation, with Catholicism, Orthodox Christianity and Islam co-existing in harmony, together contributing to the spiritual prosperity of the region. Sadly, however, subsequent history proved this to be an unattainable dream in Mucha's lifetime.

The project was realised as a mural cycle decorating the upper walls of the central exhibition hall of the Pavilion (p. 54 bottom left), which also featured the *Panorama of Sarajevo*, a diorama by the German landscape painter Adolf Kaufmann (1848–1916), together with a display of craftwork and a collection of various artefacts. Mucha placed the allegorical painting, *Bosnia Offers Her Products to the Exposition Universelle*, above the diorama, and linked together three other walls with the frieze of the 'Bosnian cycle', depicting pivotal scenes from the region's cultural development in a continuous landscape from the prehistoric era to its contemporary multi-religious society (pp. 56–57). In executing the murals, Mucha applied his distinctive decorative style as familiar from his posters and decorative panels, with strong, eloquent outlines, flatly applying lighter shades of colours with tempera and watercolour, and the motifs of trees, plants and flowers giving rhythms between the scenes.

Before starting work on the project, Mucha travelled widely through the Balkans to gather impressions and to sketch, which was reflected in his accurate depictions of folk motifs as well as archaeological and architectural details. He was particularly inspired by tragic stories from Bosnian legends and made a number of expressive charcoal and pastel drawings, sketched specifically for the Bosnian cycle. However, the completed murals show these themes only in the arched bands at the top coloured in sombre shades of blue, alluding to the spiritual world.

From this experience, Mucha conceived the idea for a new project that was to become his main focus for the rest of his artistic career. He wrote: "As I drew the epic moments in the lives of the Bosnians, I felt in my heart the joys and sorrows of my own nation and of all the other Slavic peoples. Before I had completed these Southern Slav murals, I had made up my mind about my future big work which was to become *The Slav Epic*, and I saw it as a great and glorious light shining into the souls of all people with its clear ideals and burning warnings."

Mucha's contribution to the Paris Exposition was many-sided. Officially, he was an Austro-Hungarian artist, but he was also a 'Parisian' artist of international fame. In addition to the project for the Bosnia and Herzegovina Pavilion, the assignments from the Austro-Hungarian government included

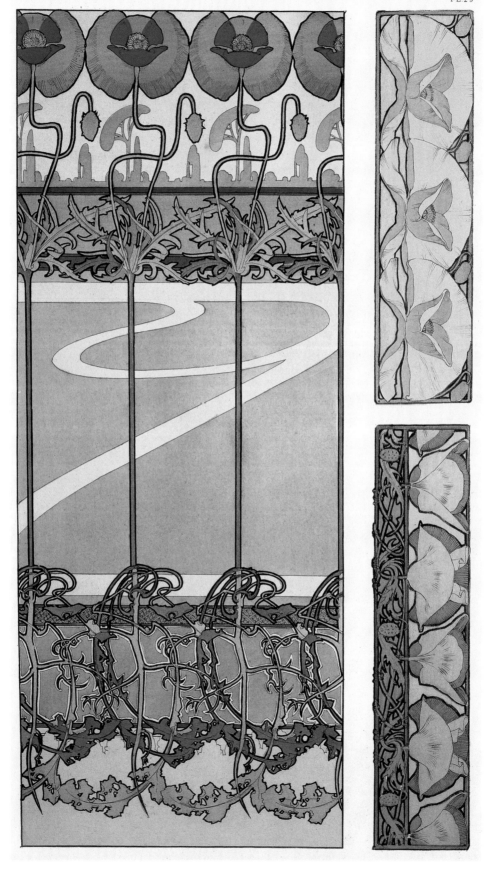

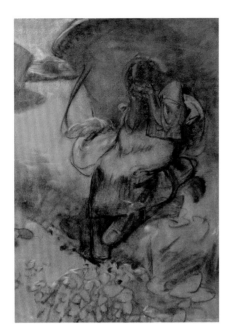

Girl Weeping, c. 1899–1900
Black chalk and pastel on paper,
47.5 x 32.3 cm / 18¾ x 12¾ in.

designs for the poster for the Austrian participation in the Exposition (p. 59) and the cover of its own official guide as well as the menu for the restaurant in the Bosnian Pavilion (p. 58). As an exhibiting artist, Mucha's works were shown in the Austrian Pavilion and in the Grand Palais (Austrian section), including *Le Pater* (pp. 52, 53) and his latest graphic works, as well as a sculpture entitled *La Nature* (p. 50). For the City of Paris, he designed the menu for the official banquet to celebrate the Exposition. Furthermore, he also worked on private commissions from the Parisian jeweller Georges Fouquet (1862–1957) and the renowned French perfumery Houbigant. Mucha contributed designs for jewellery (see p. 51) and display cases for Fouquet's stand, and undertook the decoration of the Houbigant stand, which featured ornamental statuettes and four decorative panels personifying the scents of rose, orange blossom, violet and buttercup.

This last world's fair of the 19th century was intended to celebrate the achievements of mankind over the past 100 years and to welcome in a modern new century. The Exposition of 1900 had a record number of participants – from 58 countries and over 76,000 business exhibitors, of which nearly half were from France and its colonies, each represented by an individual pavilion. On the other hand, the Czech presence at the Exposition was humble; only a small number of businesses and organisations from Prague could afford to participate in the event and all the Czech work was incorporated into the Austrian presentation, along with the other nations under the Empire's administration. It was therefore the 'Parisian' Mucha who became the most conspicuous representative of the 'Czech work'. For his contribution to the Exposition Mucha was granted honours by both the Austro-Hungarian Empire (Knight of the Order of Franz Joseph I) as well as the French Government (Legion of Honour).

After the Paris Exposition of 1900, Mucha continued to be busy with commissions for decorative works, despite his wish to start working on his plan for a Slav epic. Nevertheless, the two projects that developed at this time summarise Mucha's important contribution to the Art Nouveau style and philosophy: the design of a new Boutique Fouquet and the publication of *Documents décoratifs*.

Since around 1898 Mucha had been collaborating with Fouquet, who had been seeking inspiration for a new jewellery design. Mucha's jewellery, which looked as if it had sprung straight from his well-known posters, became a great success, and led to Fouquet's commission to design his new shop. Mucha conceived the project as a total work of art, designing not only the interior and furnishings but also the façade, uniting all the ornamental elements under a coherent decorative scheme (pp. 60–61). The new Boutique Fouquet opened in 1901 in the rue Royale, the heart of Paris. It received great critical acclaim and was regarded as "a shop of a new type" that was raised to the level of art, in which Fouquet's jewellery was displayed in total harmony with the environment.

Mucha's *Documents décoratifs* (pp. 62, 63) was published in Paris in 1902 by the Librairie Centrale des Beaux-Arts, as a folio of 72 plates presenting his decorative work. Mucha conceived this as a handbook for artisans and manufacturers, showing the analytical study of forms from nature and their practical use. These design samples, ranging from cutlery, tableware and jewellery to furniture, light fittings and wallpaper, show his boundless imagination to create new forms from motifs from nature and from the human body. The

Documents décoratifs was considered an invaluable textbook for arts and crafts students and was used by art schools in France and elsewhere in Europe as well as in Russia. Thus the publication fulfilled its author's ideal – the creation of art for the benefit of society. In the Preface the art critic Gabriel Mourey (1865–1943) wrote: "In contrast to so many of his colleagues who practise their art without a philosophical basis, he [Mucha] possesses set notions and precise ideas on the future, the goal and the mission of decorative art. If these solid principles do not suffice to make an artist, they are powerful aids to the development of the talents and the instinct without which that privileged being cannot exist."

During this same period in which Mucha received the highest acclaim for his decorative works, he was also producing a large number of pastel and charcoal drawings (e.g. pp. 64, 65), which remained unseen in his lifetime. In sharp contrast to his familiar style – calculated and solidly outlined – these private drawings were executed spontaneously with quick, expressive strokes, often in dark, limited colours. With titles such as *Vision, Phantoms, Abyss* or *Dead Couple – Abandoned* (below), Mucha depicted his spiritual visions as inspired by Masonic philosophy as well as his emotional response to the darker side of humanity. This group of works, which received no scholarly attention until recent decades, seems to reflect Mucha's internal struggle, standing at the crossroads of his career, as well as his awareness of the dualistic nature of humanity, which was to develop into a belief along these lines: "Beauty is accompanied by ugliness as light by shadow; harmony in life can be preserved only when faith in human goodness is accompanied by awareness of ever-present evil."

"Art is the expression of innermost feelings … a spiritual need."
— ALPHONSE MUCHA

Dead Couple – Abandoned, *c.* 1900
Charcoal and pastel on paper,
40.3 x 57.7 cm / 15⅞ x 22¾ in.

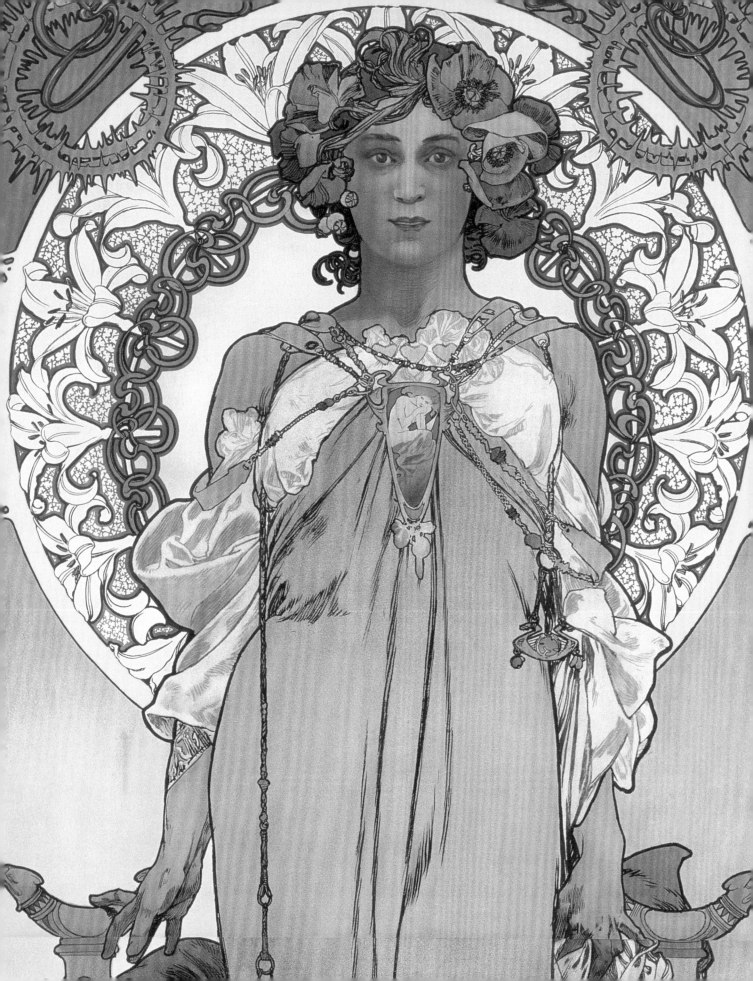

The American Interlude

On March 6, 1904 Mucha disembarked from the *La Lorraine* at the Port of New York, one of the busiest in the world. Four years after he had resolved to begin work on the project that would eventually appear as *The Slav Epic*, Mucha finally managed to take the first step towards his ambition – seeking opportunities to accumulate the necessary capital for the work. As he described in the letter quoted at the beginning of the first chapter, it took a while for him to break with the Parisian art world and try his luck in the land of opportunity. One of his most eager supporters in this move was Baroness Adèle von Rothschild (1843–1922), whose salon in Paris Mucha had frequented. Convincing him that there was a great demand for portrait painting in American high society, the Baroness introduced him to her network of friends and even arranged his first commission in New York, to paint a portrait of her relative, Helen Wissman (1866–?).

In stark contrast to his arrival in Paris 16 years before, Mucha was welcomed in America as a celebrity. His posters were already familiar to the American public, thanks to Sarah Bernhardt who had been using Mucha's designs for the publicity for her American tours since 1896. He was also a leading exponent of the dominant artistic style at the time, Art Nouveau, which had been exhibited in the Paris Exposition Universelle of 1900. Mucha's arrival in New York made the headlines in many of the newspapers and he was constantly chased by journalists and publishers during his stay. In addition, Baroness Rothschild's introduction proved highly effective: in his rented studio near Central Park, while Mucha was busy working on the portrait of Mrs Wissman he was also entertaining society ladies from New York, Chicago and Philadelphia, and juggling invitations to fashionable soirées and banquets as well as requests for talks.

In the midst of overwhelming public attention, Mucha was astounded by the large posters showing his own life-size portrait, which were displayed on billboards all over New York (p. 68). The posters were advertising Mucha's allegorical drawing, *Friendship*, produced for *The New York Daily News* and which appeared on the front page of the paper's Art Supplement for Sunday April 3, 1904 (see p. 69). In devoting this issue to Mucha, the paper hailed him as "the Greatest Decorative Artist in the World", whilst on the same day *The New York Herald* also featured a tribute to him under the heading, "Mucha, Prince of Poster Artists". Mucha was pleased by America's enthusiastic welcome but also

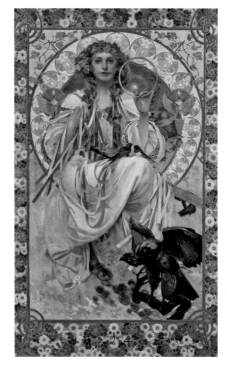

Portrait of Josephine Crane Bradley as Slavia,
1908
Oil and tempera on canvas, 154 x 92.5 cm /
60⅝ x 36⅜ in.
Prague, National Gallery

OPPOSITE
[Mrs] Leslie Carter (detail), 1908
Poster for *Kassa*
Colour lithograph, 209.5 x 78.2 cm /
82½ x 30¾ in.

OPPOSITE
The New York Daily News: Sunday Art Supplement devoted to Mucha, April 3, 1904

Billboard in New York advertising Mucha's lithograph, *Friendship* (1904)

felt ambivalent: after all, his fame here as well was confined largely to his posters. Furthermore, he was beginning to realise that it would not be as easy as he had expected to reach his financial goal just by working as a society portrait painter.

Nevertheless, and despite his short stay of less than three months, the trip was worthwhile for Mucha in terms of gaining a foothold in the New World, especially with regard to the rapidly growing Czech and Slavic communities. During this period, fighting in the Russo-Japanese War, which had broken out in February, was becoming more intense. To demonstrate his Pan-Slavic sentiment, Mucha attended a banquet in support of Russia, held at the famous Delmonico's restaurant in New York, and there met Charles Richard Crane (1858–1939), a wealthy businessman from Chicago, a philanthropist and Slavophile, who was later to play the pivotal rôle in the development of Mucha's *Slav Epic* project. On this same occasion Mucha also took the opportunity to found the American Slav Association. This was to develop into the Slavic American Cultural Association Inc., established in New York, which represented 12 ethnic groups and promoted "the contributions of Slavs to American life … as a cultural and political force".

On his return to Europe at the end of May 1904, Mucha was preoccupied by plans for his work in America, while endeavouring at the same time to complete the last commissions from various Parisian publishers, including 40 drawings for *Figures décoratives*, to be published in 1905 as a sequel to his hugely popular *Documents décoratifs* (1902). Concurrently, he also began to work on *Madonna of the Lilies* (p. 70), a painting intended to form his decorative scheme for a church in Jerusalem, which had been commissioned in 1902 but was cancelled later in 1905. Even so, his concept for a stained-glass window for the same project in Jerusalem (p. 71) would go on to be developed in America as a monumental painting, *Harmony* (1908). By the end of 1904, Mucha had managed to terminate his contracts with Champenois and other Parisian publishers, and he set off for New York again in early January 1905.

Between the winter of early 1905 and 1910, Mucha visited America four times. On three of these occasions his stay lasted five to six months, but in the autumn of 1906, when he went to America with his newly-wed wife, Marie (Maruška) *née* Chytilová (1882/3–1959), he stayed until the summer of 1909; their first child, Jaroslava (1909–1986), was born in New York that year.

Mucha's regular source of income in America came from teaching. In 1905 he began to teach illustration and design at the New York School of Applied Design for Women, while also giving private lessons in his 'Atelier Mucha'. In 1906 he was invited to lecture at the Philadelphia School of Art for five weeks, and later the same year he became a visiting professor at the Art Institute of Chicago, where his students included popular illustrators such as J. C. Leyendecker (1874–1951) and Edward Arthur Wilson (1886–1970). Mucha was a popular teacher, with a clear vision concerning art and the artist and well-devised theories that had evolved from his experience as a top graphic designer in Paris. His surviving lecture notes, which were compiled and published posthumously in 1975 as *Alphonse Mucha: Lectures on Art*, give a glimpse of his artistic philosophy: the goal of art is the expression of "beauty", by which Mucha meant "moral harmonies"; the role of the artist is to arouse the interest of the viewer in the artist's message and "to communicate with the souls of man". The "exterior form is a language" for this communication and so the artist should endeavour to create as effective a visual language as possible.

The New York Daily News

COLORED SECTION

TEN ART PAGES

NEW YORK, SUNDAY, APRIL 3, 1904.

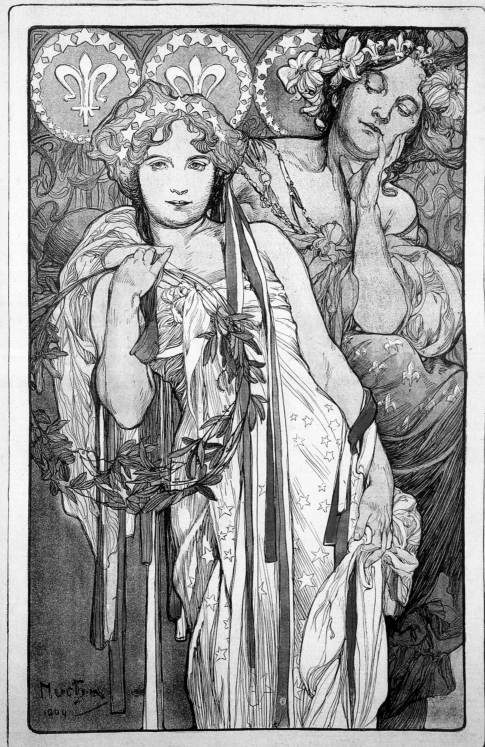

FRIENDSHIP

DRAWN
FOR THE
New York
Daily News
BY
ALPHONSE
MUCHA

COPY-
RIGHTED
1904
BY
FRANK A.
MUNSEY

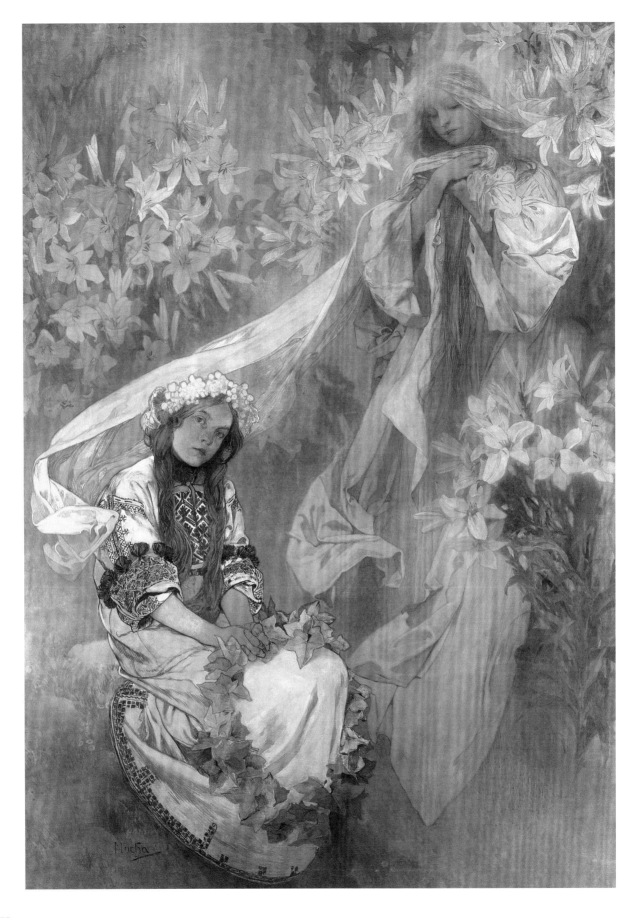

While he was working in America, Mucha generally declined commissions that were in essence commercial. However, he occasionally worked on magazine covers and advertising posters, when pressed by financial necessity. One of the most conspicuously commercial works was in 1906 for 'Savon Mucha', a soap packaging commission from Armour & Co., a Chicago-based manufacturer. Mucha was asked to design the soap boxes and the store display (p. 72), which he produced in the style of his Parisian decorative panels. The soap was named after Mucha to boost publicity and sales, making him the first 'celebrity artist' to become the brand name of a household product.

The most ambitious project Mucha undertook in America was the decoration of the German Theatre in New York. Financed by the German community, it opened in October 1908 at the corner of Madison Avenue and 59th Street, and Mucha was asked by the theatre's director, Maurice Baumfeld (1868–1913), to decorate the whole of the interior. In Mucha's decorative scheme, which was executed in elaborate Art Nouveau style, the highlight was the three allegorical paintings decorating the proscenium: *Tragedy* (p. 73 left) and *Comedy* (p. 73 right) on either side of the stage, and *Truth (Quest for Beauty)* (1908) above it. The project also included graphic works as well as stage and costume designs for several plays. After the Boutique Fouquet in Paris, the German Theatre was Mucha's most comprehensive work of interior decoration, and his murals, in particular, were highly praised, as, for example, the reporter for *International Studio* wrote: "One of Mucha's finest achievements, in which he reached the very maturity of his powers of expression." However, to Mucha's disappointment, the theatre was closed down after a single unsuccessful season – the building was converted into a cinema in late 1909 and eventually demolished in 1929.

Mucha's further involvement in theatre included collaborations with Mrs Leslie Carter (1862–1937), known as 'the American Sarah Bernhardt', and Maude Adams (1872–1953), a top star on Broadway. Mucha designed a poster (pp. 66,

Madonna of the Lilies, 1905
Tempera on canvas, 247 x 182 cm / 97 x 71½ in.

Mucha called his subject here "*Virgo purissima*", and in doing so depicted the Madonna as a spiritual being surrounded by white lilies, a symbol of purity, and a figure whose mystical power radiates from her light. At her feet is a young Slavic girl in prayer, holding a wreath of ivy leaves. The girl is unaware of the heavenly presence but the Madonna's long veil gently touches her with a blessing.

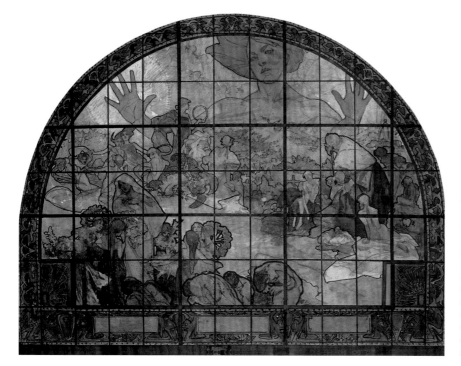

Harmony, c. 1904–1905
Design for a stained-glass window for a church in Jerusalem (unrealised)
Pencil, ink, watercolour and chalk on paper, 90 x 130 cm / 35 x 51 in.

In this semi-circular format, Mucha's design features the enormous half-figure of 'Harmony' appearing over the horizon, symbolising the force which governs the harmonious working of nature and human life. A similar idea and composition were explored in earlier works, such as *Le Pater* (pp. 52, 53).

75), stage sets and costumes for Mrs Leslie Carter's new play, *Kassa*, which was premièred in New York in January 1909 but ended in bankruptcy – Mucha never succeeded in recovering his fees for this project. Disaster here was followed, however, by success in the same year, with Maude Adams's one-night performance of Schiller's *Maid of Orleans*, which was staged at the Harvard Stadium on June 21, 1909 with Adams in the starring rôle as Joan of Arc. For this production, Mucha produced costume and set designs as well as an oil portrait of Adams in costume, which was displayed before the performance as if it were the poster. For both the Carter poster and the Adams portrait, Mucha used the same design formula he had used for the Sarah Bernhardt posters.

As a portrait painter, Mucha's best work in America was *Slavia* (p. 67), depicting Josephine Crane Bradley (1886–1952), the eldest daughter of Charles Crane, who had been in contact with Mucha since 1904. The painting was Crane's wedding gift for his daughter when she got married to Harold Cornelius Bradley (1878–1976) in July 1908. At Crane's request, Mucha represented Josephine as Slavia, the goddess who personified the Slavic people. Shortly after this, Mucha was also commissioned to paint the portrait of Crane's second daughter, Frances Crane Leatherbee (1887–1954), but struggled to finish this. Like many of the portrait assignments he undertook in America, the work dragged on as a dissatisfied Mucha kept repainting and retouching; he finally managed to finish the portrait in 1913. The comparison between the two portraits reveals Mucha's unease with the conventional style of society portraits. Inspired by Crane's suggestion, *Slavia* was painted in his mature decorative style with rich symbolism, capturing the charm of the American heiress in the guise of the Slavic goddess, the theme close to his heart. On the other hand, the Leatherbee portrait, in the grand manner à la Sargent, shows the sitter in a characterless pose, reflecting Mucha's lack of interest.

Since he was teaching regularly in Chicago, which was then the largest centre of Czech immigration in America, Mucha had plenty of opportunities to meet Crane, whose family business, Crane Company, was also based in the city. Crane was also the founder of a school of Russian and Slavic studies at the

"The marvellous poem of the human body, or those of animals, and the music of the lines and colours which emanate from flowers, leaves and fruits, make themselves incontrovertibly educators of our eyes and taste."

— ALPHONSE MUCHA

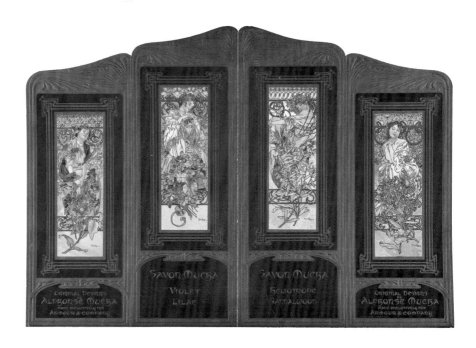

Savon Mucha, 1906
Point-of-purchase display incorporating four miniature decorative panels: Lilac, Violet, Sandalwood and Heliotrope
Colour lithograph and gold ink, printed on card, 41.9 x 61.2 cm / 16½ x 24⅛ in.

Tragedy, 1908
Study for a mural for the
German Theatre in New York
Oil and tempera on canvas,
117 x 58.5 cm / 46 x 23 in.

Comedy, 1908
Study for a mural for the
German Theatre in New York
Oil and tempera on canvas,
117 x 58.5 cm / 46 x 23 in.

This pair of paintings show a striking contrast
in mood, while their compositions form a sym-
metrical harmony. *Tragedy* is represented by a
melancholy woman cradling a dead young
man, the scene overshadowed by a towering
dark figure in the background. *Comedy* shows
a spring scene with a blossoming tree, in which
a lute-player plays a sweet melody of love; the
motif of 'Harmony' (see p. 71) appears in the
sky, bestowing her blessing upon everything.

University of Chicago, and for this in 1902 invited the Czech philosopher and
future president of Czechoslovakia, Tomáš Garrigue Masaryk (1850–1937), to
attend as a visiting professor. During 1908, Crane and Mucha met often in Cape
Cod, where the latter was working on *Slavia* and the German Theatre murals in
his friends' boathouse. Mucha was impressed by Crane's profound understand-
ing of Slavic affairs, while Crane was interested in Mucha's vision of the Slavs in
a future Europe. Through Crane, Mucha also met Thomas Woodrow Wilson
(1856–1924), then a Princeton scholar with a special interest in Eastern Europe,
who was to become the 28th President of the United States in 1913.

Mucha's concept for *The Slav Epic* was being consolidated in the course of
1908–1909, and discussions with both Crane and Wilson contributed to the
process. After having seen Mucha's preliminary sketches for the first three
paintings, Crane finally agreed on Christmas Eve, 1909 to sponsor the project.
In February 1910 Mucha wrote to Maruška, then in Prague, to say that he was
looking for a "new approach" to painting for this project, and that he "will be
able to do something really good, not for the art critic but for the improvement
of our Slav souls."

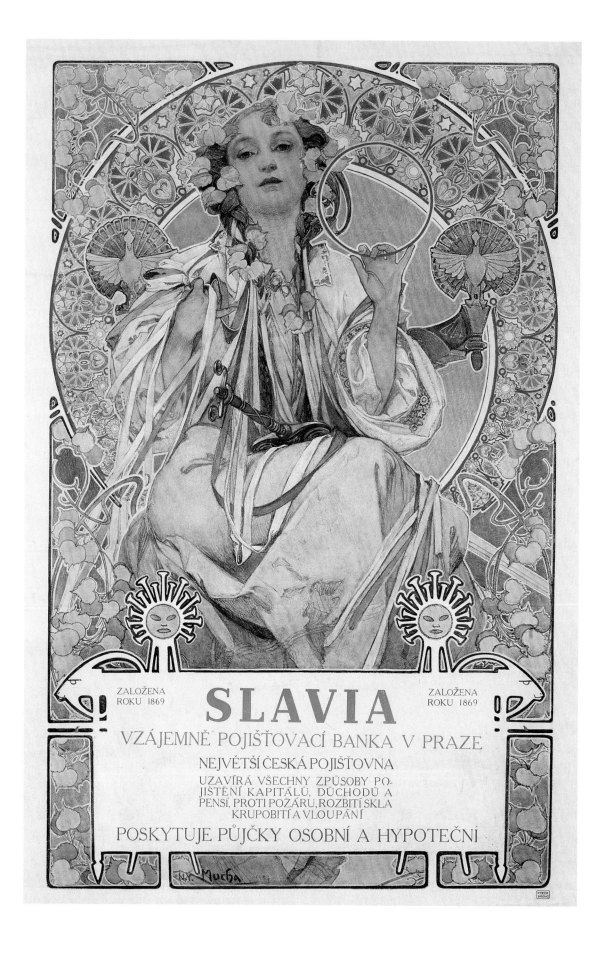

[Mrs] Leslie Carter, 1908
Poster for *Kassa*
Colour lithograph, 209.5 x 78.2 cm /
82½ x 30¾ in.

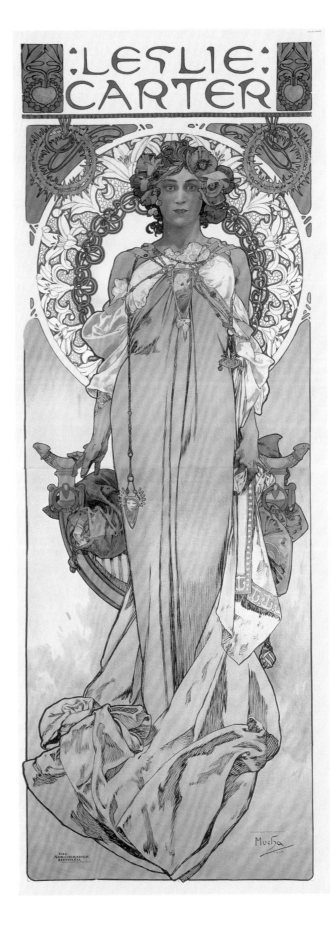

OPPOSITE
Slavia Insurance Bank in Prague, 1907
Colour lithograph, 55 x 36 cm / 21⅝ x 14⅛ in.

During his stay in America Mucha was
commissioned to design a poster for the Slavia
Insurance Bank in Prague, and from this design
he developed the composition for the *Slavia*
portrait painted the following year (p. 67). In
both works the subject is depicted as the Slavic
goddess in a ceremonial white gown, holding
the circular band symbolising Slavic unity and
seated on a metaphorical throne decorated with
two doves of peace.

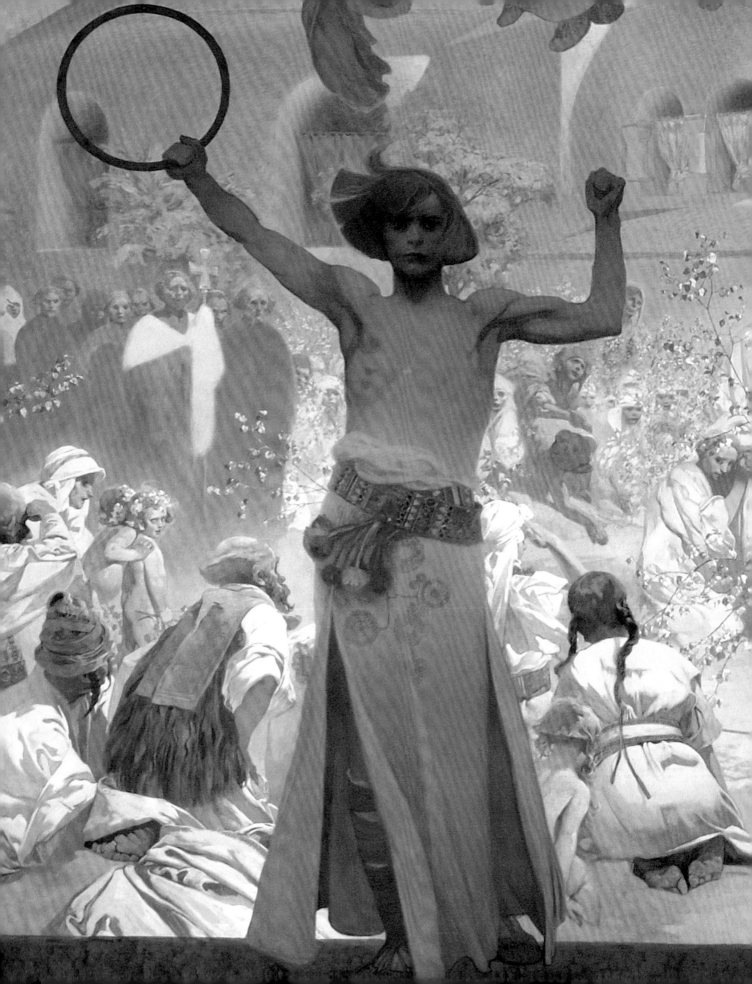

The Slav Epic – a Light of Hope

In the spring of 1910 Mucha finally returned to his homeland after an almost continuous absence of 25 years. Because of this, some of his fellow Czech artists regarded Mucha as an 'outsider', despite his occasional visits to family and friends as well as his numerous works reproduced in Czech books and magazines. In 1902, during a trip home on which he accompanied his friend Auguste Rodin (1840–1917) on the occasion of an exhibition of the latter's work in Prague, Mucha urged Czech artists on the need to establish their national identity in art, independent of the foreign models from "Vienna, Munich and Paris". However, the Czechs viewed his remarks as a double standard – criticism from someone who had himself abandoned his homeland for personal success abroad. This unfortunate misunderstanding, which arose from an ironic 'culture' gap – between Mucha's lofty idealism as formed by his expatriate experience, and the perception of insiders as regards the ways Czech life was responding to day-to-day changes – caused animosity among the Prague artists, which was to cast a shadow over Mucha's work in his homeland.

The bitterness that germinated in 1902 developed into a major controversy in 1909, when Mucha was offered the job of decorating the newly built Municipal House (Obecní dům) in Prague. Designed by Antonín Balšánek (1865–1921) and Osvald Polívka (1859–1931), the magnificent Art Nouveau building was conceived as an expression of Czech civic pride, counterbalancing the German House standing nearby. Mucha regarded the project as "a great opportunity to serve his nation", and was willing to undertake the commission for a modest fee, mainly to cover material costs. However, the Prague artists were outraged to hear that this important project had been offered to Mucha the outsider alone. Eventually a compromise was made: while Mucha was given responsibility for the Lord Mayor's Hall, the rest of the work was divided among several well-known Prague artists, including Mikoláš Aleš (1852–1913) and Max Švabinský (1873–1962). In this way Mucha landed his first official work for his nation in 1910, before concentrating on the *Slav Epic* project.

The Lord Mayor's Hall was situated within the domed central façade of the Municipal House, and Mucha's design conceived its circular space in terms of a monument to inspire Slavic unity, through which, in his belief, the restoration of the Czech nation would be realised. Expressing this ideal, Mucha's 11 murals were incorporated into the architectural language of the space (p. 78

Jaroslava posing for *The Oath of Omladina under the Slavic Linden Tree* (1926; cycle No. 18 from the *Slav Epic*); the canvas of *King Přemysl Otakar II of Bohemia* (1924; cycle No. 5 from the *Slav Epic*) can be seen in the background, *c.* 1925
Photograph from original glass-plate negative

OPPOSITE
The Slav Epic (cycle No. 3):
The Introduction of the Slavonic Liturgy
(detail), 1912
Egg tempera and oil on canvas, 610 x 810 cm /
240 x 320 in.
Prague, City Gallery

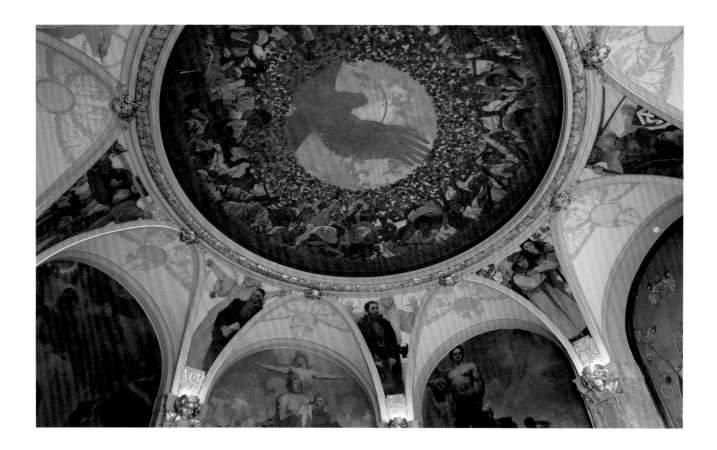

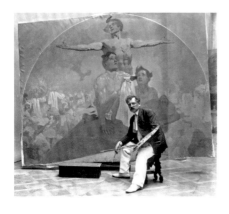

top): the round ceiling painting *Slavic Concord* is 'carried' by the eight pendentives featuring Czech historical characters embodying the civic virtues that constitute the foundations of the nation. Beneath this framework, the powerful figures of Czech youths featured in the 'triptych' send out their patriotic messages. With the coherence of idea and design, as well as the masculinity, which showed a sharp contrast with his Parisian decorative style, Mucha's murals here show the move towards a new phase in his art.

After the completion of his work for the Municipal House in 1911, Mucha was finally able to devote himself properly to *The Slav Epic*, which by this time had been planned as a series of 20 paintings, each with a proposed size of approximately seven by nine metres (the seven largest of the paintings that were actually produced in fact measure approximately six by eight metres). In order to work on such enormous canvases, Mucha rented an apartment and a spacious studio in the Zbiroh Castle in western Bohemia, where he and his family were to stay until 1928. His second child Jiří was born in 1915, and both Jiří and his elder sister Jaroslava were thus to spend their formative years at Zbiroh (see p. 93 right), witnessing the development of *The Slav Epic* and from a young age also posing for their father as models (scc p. 77).

The Slav Epic, which Mucha had envisioned in *fin-de-siècle* Paris as a "light shining into the souls of all people with its clear ideals and burning warnings", was now developing into a monument for Slavic unity – a spiritual home for all Slavs wherein they might learn lessons for the future from their history. Under the contract made between Mucha, Crane and the City of Prague, the *Epic* was to be donated to Prague upon its completion, the city in turn being obliged to provide a dedicated home for it.

For this ambitious pictorial 'thesis', Mucha made thorough preparations. He read a variety of books by historians, including František Palacký (1798–1876), a leading figure of the Czech National Revival and often called 'Father of the Nation'. Mucha also consulted with contemporary scholars such as Ernest Denis (1849–1921), the French expert on Slavic history, as well as Nikodim Kondakov (1844–1925), the Russian specialist on Byzantine art. Furthermore, he made many research trips – to Croatia, Serbia, Bulgaria, Montenegro, Poland, Russia and Greece – sketching, photographing and studying local customs and traditions.

In order to conceptualise *The Slav Epic*, Mucha selected the 20 key historical episodes which, in his view, had influenced the development of Slavic civilisation. Covering a wide range of themes from politics and war to religion, philosophy and culture, 10 episodes were taken from Czech history and the remaining 10 were historical scenes from the past of other Slavic nations. In this selection process, Crane gave free rein to Mucha, except for *The Abolition of Serfdom in Russia* (below), a subject specifically requested by Crane, who also wished the painting to be based on Mucha's "first-hand observations" of the Russian people. To fulfil his sponsor's wish, Mucha visited Russia in 1913 and produced an impressive collection of documentary photographs capturing images of Tsarist Russia in its last year of relative peace.

Photography played an important part in the making of *The Slav Epic*, and as a photographer Mucha entered a new stage with this project. His *mise-en-scène* practice became more structured under the strong theatrical direction he employed to build up a coherent drama for each scene (e.g. p. 82 bottom).

PAGES 80–81
Mucha at the first *Slav Epic* exhibition at the Klementinum in Prague, 1919
Photograph from original glass-plate negative

The Slav Epic (cycle No. 19):
The Abolition of Serfdom in Russia, 1914
Egg tempera and oil on canvas,
610 x 810 cm / 240 x 320 in.
Prague, City Gallery

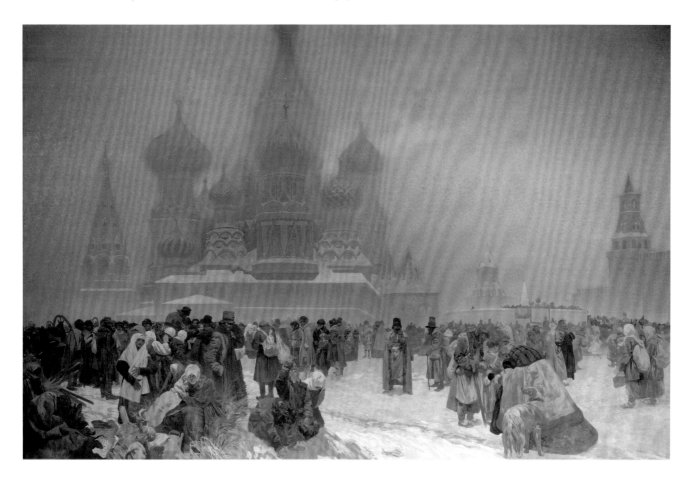

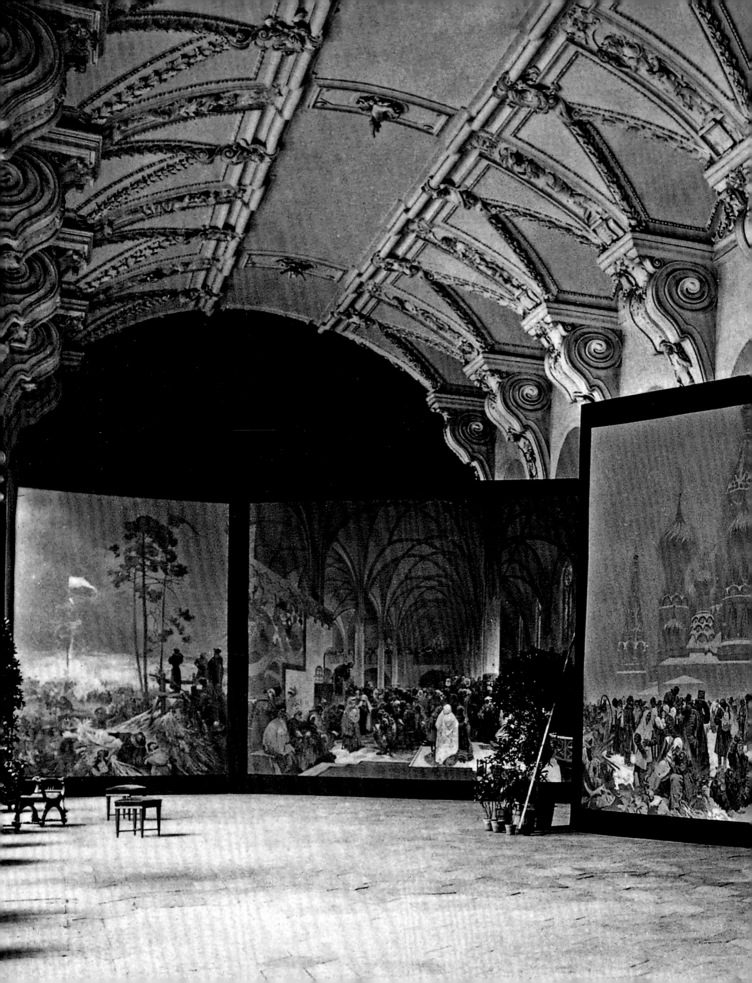

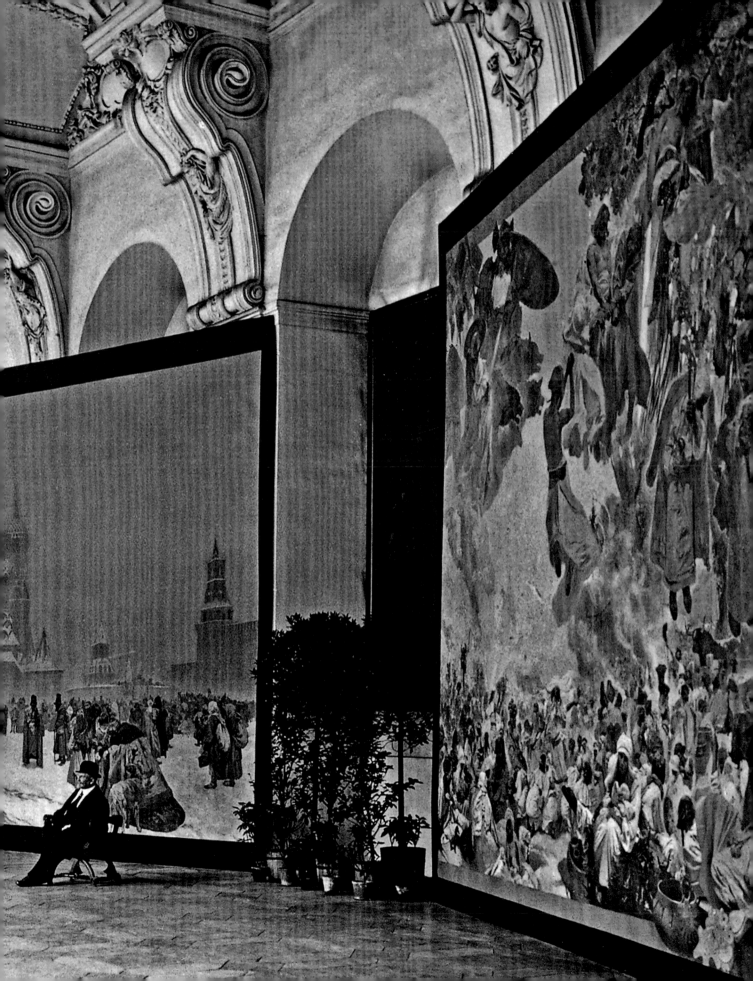

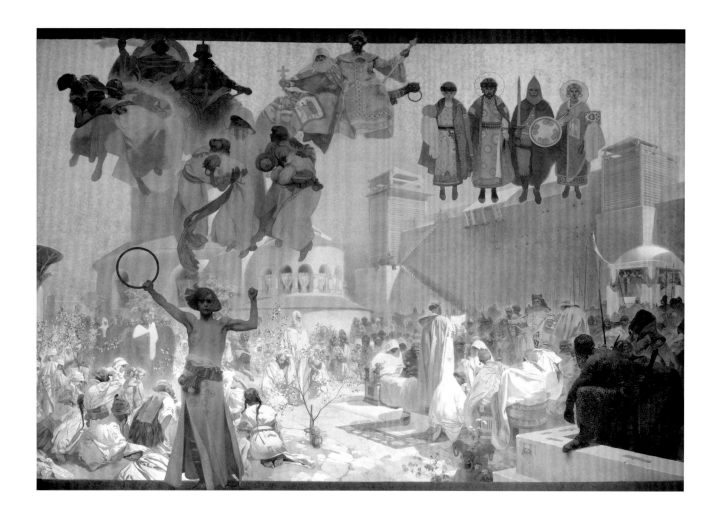

The Slav Epic (cycle No. 3):
The Introduction of the Slavonic
Liturgy, 1912
Egg tempera and oil on canvas,
610 x 810 cm / 240 x 320 in.
Prague, City Gallery

Models posing for *The Slav Epic (cycle No. 2):*
The Celebration of Svantovít (1912), *c.* 1911–1912
Photograph from original glass-plate negative

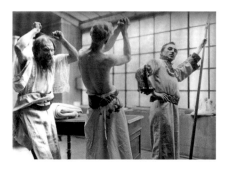

Mucha's photographs of costumed models, many in filmic sequences, indicate the encouragement he gave to the models to move spontaneously and interact with each other rather than to strike a fixed pose individually. Additionally, his research trips generated numerous documentary photographs of people and their lives as well as the events he encountered. Although these photographs were meant to be simply a supplement to his sketches, many of them convey Mucha's warm gaze on human life.

Painting such unusually large canvases posed a variety of technical problems, but Mucha overcame the difficulties with various innovations. First of all, to maintain the rigidity of the canvases, he built perforated metal frames on to which the canvases could be fastened with ropes; they were also fitted with grooved wheels to make them easier to move about. In order to reach the upper parts of the canvases, he constructed metal scaffolding with casters, furnished with multiple platforms. For the painting, Mucha decided to use egg tempera. This fast-drying medium was suitable for his painting method and for achieving a luminous effect, while according to his research on Renaissance fresco paintings, egg tempera would be more durable than oil. However, oil was also used to render details and was mixed with tempera in places to enhance luminosity.

The *Slav Epic* canvases were completed between 1912 and 1926. As a whole, the series expressed Mucha's visionary perspective of Slavic history spanning more than 1,000 years. Beginning with *The Slavs in Their Original Homeland*

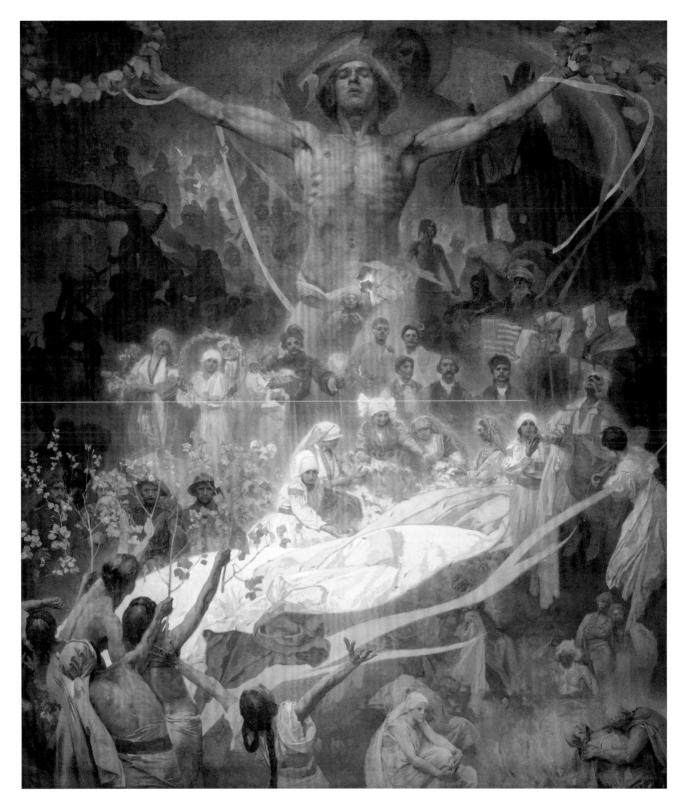

The Slav Epic (cycle No. 20):
The Apotheosis of the Slavs:
Slavs for Humanity, 1926
Egg tempera and oil on canvas,
480 x 405 cm / 189 x 159 in.
Prague, City Gallery

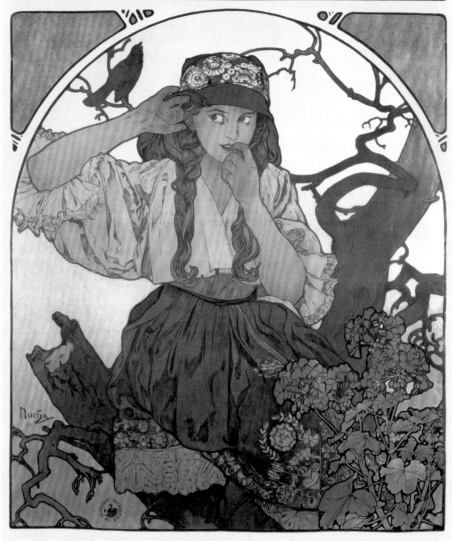

OPPOSITE
Princess Hyacinth, 1911
Colour lithograph, 125.5 x 83.5 cm /
49½ x 32⅞ in.

The poster features a portrait of the popular
actress Andula Sedláčková (1887–1967) in the

title role – a blacksmith's daughter who is
transformed into a princess in her father's
dream. In this design Mucha used the circular
backdrop familiar from his Parisian posters and
incorporated the tools of the blacksmith and
other symbolic motifs within it to make refer-
ences to the plot of the ballet.

ABOVE
Moravian Teachers' Choir, 1911
Colour lithograph, 106 x 77 cm /
41¾ x 30¼ in.

Russia Restituenda [Russia Must Recover],
1922
Colour lithograph, 79.7 x 45.7 cm / 31⅜ x 18 in.

This poster served as a plea for help for starving children in the aftermath of the Russian Civil War (1917–1922), which paralysed the country and killed millions through widespread disease and starvation. A distressed peasant woman is shown holding a dying child – the image adapted from Christian iconography of the Mother and Child – and the poster was designed specifically to evoke compassion. For the message at the bottom Mucha chose to use Latin, a universal language, to indicate the impartiality and internationalism of this humanitarian effort.

OPPOSITE
Lottery of the Union of Southwestern Moravia, 1912
Colour lithograph, 128 x 95 cm /
50⅜ x 37⅜ in.

Under the Austrian regime, the Czech language could only be taught in private schools run by local communities. This poster was designed to promote a lottery for raising funds for such schools. It shows a little schoolgirl staring accusingly at the viewer while Mother Nation crouches in despair on a withered tree, with the poster thus intended to make an emotional appeal for the survival of the nation's education and culture.

(1912), which portrayed the ancient Slavs as peaceful but submissive people who were defenceless in the face of foreign aggressors, the series culminated in the final painting, *The Apotheosis of the Slavs* (p. 83), which not only depicted the eventual liberation of the Slavs from their oppressors in 1918 but also summed up Mucha's view of Slavic history and its future. While celebrating the independence of the Slavic nations as the apotheosis of their history in the centre of the composition, Mucha surrounded this contemporary event with a vortex of human figures representing the past as the basis of the present. Furthermore, he expressed his vision for the future role of the Slavs with the subtitle 'Slavs for Humanity' – the message is embodied in the figure of the girl emerging above the present, who guards in her hands the illuminating light of wisdom, which would "lead to the goodness and happiness of the rest of humanity".

While he was working on the *Slav Epic* canvases, Mucha declined any commercial work but still accepted commissions for causes that were close to his heart. He designed posters to promote Czech cultural or philanthropic events, such as the ballet-pantomime *Princess Hyacinth* at the National Theatre in Prague (p. 84), concerts by the *Moravian Teachers' Choir* in 1911 (p. 85), a lottery organised to raise funds for Czech schoolchildren in 1912 (p. 87), as well as the Sokol's 'All-Slavic' sporting festivals in 1912 and 1926. He also produced several symbolic paintings to inspire Slavic unity (e.g. p. 89), featuring images of Slavic women in traditional folk costumes, which were, in Mucha's view, not merely costumes but "the soul of the nation". When the independent state of Czechoslovakia was formed in 1918, Mucha was eager to serve his new nation and designed the first Czechoslovak stamps and bank-notes as well as a variety of state paraphernalia, including the national emblem and police uniform, for which he declined to accept any payment.

During this period, Mucha continued to practise as a Freemason, despite its having been banned under the Austro-Hungarian Empire and carrying the death penalty in wartime. After the dissolution of the Empire, Mucha played a leading role in the re-establishment of Freemasonry in the new state and in 1919 was instrumental in founding the first Czech-speaking lodge in Prague, Jan Amos Komenský, named after the 17th-century Moravian educator (1592–1670) who was known as 'the Father of Modern Education'. In 1923, Mucha was elected Sovereign Grand Commander of the Czech Supreme Council of Freemasons (see p. 94). He contributed designs for insignia and other paraphernalia for various Masonic lodges and expressed his humanitarian ideals through his Masonic publications, lobbying activities and his art. Two works from the early 1920s, the poster *Russia Restituenda* (above left) and the painting *Woman in the Wilderness* (p. 91), reflect Mucha's response to the humanitarian crisis in Russia at the time, following the Bolshevik Revolution.

In September 1928, Mucha and Charles Crane officially donated the entire cycle of *The Slav Epic* to the City of Prague, on the occasion of the 10th anniversary of the founding of the new state of Czechoslovakia. In marking the moment, Mucha addressed his nation: "I am convinced that the development of every nation can only be successful if it grows organically and uninterruptedly from its own roots, and the knowledge of its past is indispensable for the preservation of that continuity … I wanted to talk in my own way to the spirit of the nation … The purpose of my work was never to destroy but to construct, to link up, because we all must hope that humanity will draw [closer] together and this will be easier the more they understand each other.

I will be happy if it falls to my lot to have helped with my modest strength towards this understanding, at least in our Slav family."

In Mucha's lifetime, *The Slav Epic* was exhibited in Prague twice – in 1919 (see pp. 80–81) and 1928, and it also proved to be the spark for a prolonged controversy. While the 'progressive' Czech artists regarded Mucha's 'historical' paintings as anachronistic, many critics failed to look into his philosophical intention, considering his 'nationalistic' sentiment to be irrelevant after the nation's independence in 1918. Furthermore, in 1933 the *Slav Epic* canvases were rolled up and put into storage after the exhibitions in Brno and Pilsen; Mucha and Crane's contract with the municipal authorities did not specify a binding date for providing the requested permanent home for *The Slav Epic*. Many of the negative comments about the *Epic* persisted after World War II under the Communist regime and throughout the Cold War era until the Velvet Revolution of 1989; it was only during the 1990s that Mucha's homeland began to look at the meaning of *The Slav Epic* in a new light.

In 1933, celebrations for the 15th anniversary of the formation of Czechoslovakia were diminished by a looming sense of foreboding. In Germany, Adolf Hitler (1889–1945) was consolidating his power, and in Czechoslovakia Nazism was spreading among the Sudeten Germans. Amid growing anxiety, Mucha decided to make a large oil painting depicting the horrors of war, featuring the motif of the girl guarding the illuminating light from the last

Song of Bohemia (Our Song), 1918
Oil on canvas, 100 x 138 cm / 39½ x 54½ in.

At the time Mucha produced this painting, he could perhaps sense his dream coming true, since in June 1918 the Allied governments officially recognised the Czechoslovaks' national aspiration. The painting was reproduced in the July 10, 1918 issue of *Zlatá Praha* under the title *Our Song*.

OPPOSITE
The Slav Epic, 1928
Colour lithograph (upper sheet of the two-part poster), 123 x 81.2 cm / 48⅜ x 32 in.

This poster was designed for the exhibition of the completed *Slav Epic* at the Trade Fair Palace in Prague in 1928, on the occasion of the 10th anniversary of the creation of Czechoslovakia. It features the motif of the allegory of music taken from *The Oath of Omladina under the Slavic Linden Tree* (1926) (see p. 77).

The Light of Hope, 1933
Oil on canvas, 96.2 x 90.7 cm /
37⅞ x 35¾ in.

*"The artist must remain faithful
to himself and to his national roots."*
— ALPHONSE MUCHA

painting of *The Slav Epic, The Apotheosis of the Slavs: Slavs for Humanity*
(p. 83). The project never came to fruition but in the surviving oil study, en-
titled *The Light of Hope* (above), the girl's figure clearly embodies Mucha's paci-
fist message, standing out from the darkness within which terrified individuals
flee from the horrors of war.

In 1936, Mucha's artistic achievement was celebrated in Paris by a large
retrospective, organised by the Musée du Jeu de Paume, which also included
work by his old Czech friend, František Kupka (1871–1957). Mucha was repre-
sented by 139 works, including three canvases from *The Slav Epic.* However,
the political situation in Europe was developing rapidly in the direction
Mucha had most feared. Acutely sensing the possibility of another war, the
76-year-old Mucha launched into a new project: a triptych depicting *The Age
of Reason, The Age of Wisdom* and *The Age of Love* (1936–1938). For this work
he intended to use canvases as large as those of *The Slav Epic* and wished to
make the triptych a monument for all mankind. The themes addressed here –
Reason, Wisdom and Love – were, in Mucha's view, the three key attributes of
humanity. According to his notes he considered Reason and Love to be two
extremes that could only be balanced through Wisdom, and thus believed that
the harmony of the three elements would contribute to the progress of man-
kind. Unfortunately, Mucha did not live long enough to complete this project.

On the morning of March 15, 1939, Mucha saw German troops marching
through Prague; the following day, Hitler proclaimed the establishment of the
German Protectorate of Bohemia and Moravia at Prague Castle. Shortly after-

wards, Mucha was arrested by the Gestapo as a prominent Czech patriot and Freemason, and although he was released after several days of questioning, his spirit was broken and his health was suffering. Mucha died of pneumonia on July 14, 1939. Despite the banning of public gatherings and speeches, Mucha's funeral was attended by a huge crowd of people – both admirers and opponents. Alphonse Mucha was laid to rest in the Slavín Monument – the 'Pantheon' of great Czechs established in 1893 in Prague's Vyšehrad cemetery. Surmounted by a statue of the Genius Patriae, the monument carries the inscription: "Although dead, they still speak to us."

Woman in the Wilderness, 1923
Oil on canvas, 201.5 x 299.5 cm / 79½ x 118 in.

Mucha produced this symbolic painting in response to the sufferings endured by the Russian people after the Bolshevik Revolution. The picture shows a lone peasant woman stranded in the dark snowfields, with a pack of wolves appearing from behind the hill. Mucha expressed the helplessness of the Russian people's situation and their sorrow through the figure of the woman stretching her hands out to accept her inevitable fate.

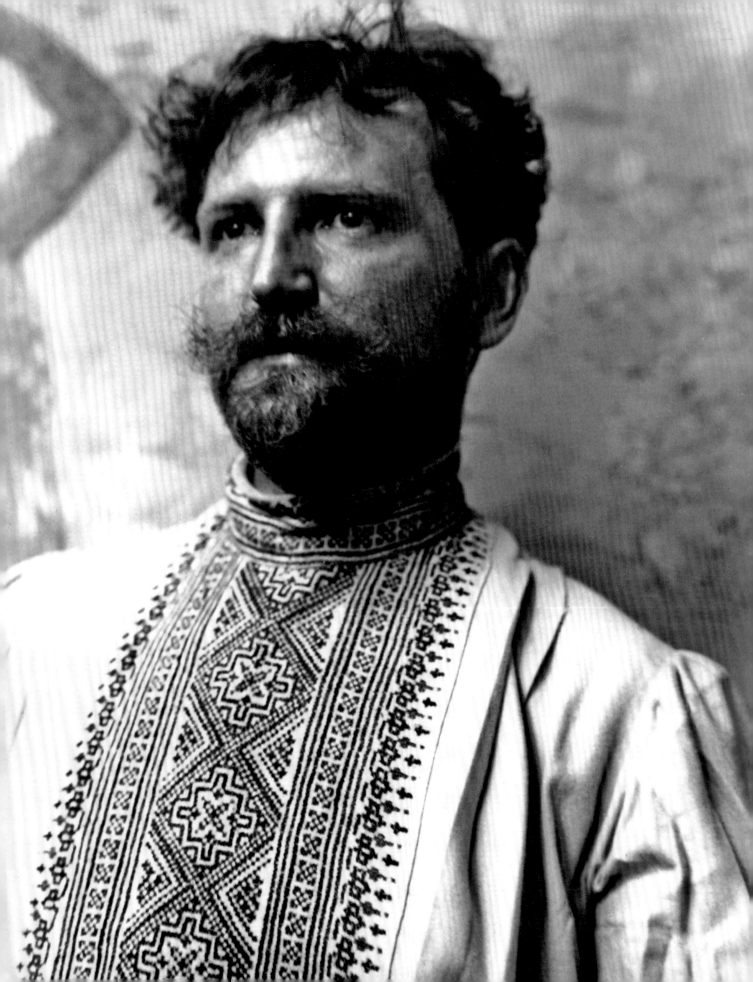

Alphonse Mucha 1860–1939
Chronology

1860 Born in Ivančice in South Moravia on July 24 to the family of Ondřej Mucha, a court usher.

1872 Wins a choral scholarship to the Cathedral of Saints Peter and Paul in Brno, the capital of Moravia, where he also attends the Slovanské Gymnasium. Meets the future composer Leoš Janáček.

1877 Returns to Ivančice, where his father finds him work as a court clerk.

1878 Mucha's application to the Prague Academy of Fine Arts is turned down. Continues to work at the courtroom, while involved in amateur theatre groups as well as contributing designs for local patriotic organisations and magazines.

1879 Goes to Vienna late in the year to work as an apprentice scene painter for the firm of Kautsky-Brioschi-Burghardt.

1881 Begins taking photographs with a borrowed camera around this time. At the end of the year, dismissed from work after a major fire burnt down the Ringtheater, his employer's best customer.

1882 Early on goes to Mikulov, where he earns a living by painting portraits. By 1883, meets the local landowner, Count Eduard Khuen-Belasi, who employs Mucha to decorate his residence, Emmahof Castle (see p. 10), and later Gandegg Castle in the Tyrol for his brother Count Egon.

1885 Begins studies at the Munich Academy of Fine Arts, with the sponsorship of Count Eduard. Joins the Škréta Club, a society of Czech and Slavic art students in Munich. Commissioned to paint an altarpiece, *Saints Cyril and Methodius*, for the Church of St. John of Nepomuk for a Czech community in Pisek, North Dakota, USA (p. 12).

1887 Moves to Paris to study at the Académie Julian, sponsored by Count Eduard Khuen-Belasi.

1888 Enters the Académie Colarossi.

1889 The Count's sponsorship ends; begins to work as an illustrator for publishers in Paris and Prague.

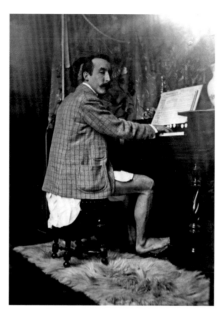

1890 Moves to lodgings above Madame Charlotte Caron's Crèmerie at 13, rue de la Grande Chaumière.

1891 Meets Paul Gauguin, who stays briefly at Mme Charlotte's before his first trip to Tahiti. Begins working for Parisian publisher Armand Colin, who commissions Mucha to illustrate *Scènes et Épisodes de l'Histoire d'Allemagne* by Charles Seignobos (p. 16).

1892 Begins to give drawing lessons at his studio, which later develop into the 'Cours Mucha' at the Académie Colarossi.

1893 Purchases his own camera around this time. Gauguin returns from Tahiti and shares Mucha's studio at 8, rue de la Grande Chaumière.

1894 Awarded a '*mention honorable*' at the Paris Salon for oil studies for *Scènes et Épisodes de l'Histoire d'Allemagne*. Meets Swedish dramatist and writer August Strindberg, who is among the *habitués* at Madame Charlotte's until 1896. Late in December, designs his first poster for Sarah Bernhardt, *Gismonda* (pp. 23, 25).

1895 Signs a six-year contract with Bernhardt to design posters, stage sets and costumes for her productions. Meets the Lumière brothers, pioneers of film-making.

ABOVE LEFT
Paul Gauguin playing Mucha's harmonium at his studio in the rue de la Grande Chaumière, Paris, 1893

ABOVE RIGHT
Maruška with daughter Jaroslava (left) and son Jiří (right) at Zbiroh Castle, western Bohemia, *c.* 1917

OPPOSITE
Self-portrait in a Russian 'rubashka' shirt at his studio in the rue de la Grande Chaumière, Paris, early 1890s

1896 Joins the Salon des Cent, the group of artists promoted by *La Plume* magazine. Signs an exclusive contract with Parisian printer F. Champenois. Moves to a larger studio and apartment at 6, rue du Val-de-Grâce. Designs his first series of *panneaux décoratifs*, *The Seasons* (pp. 38–39). Participates in the Exhibition of Artistic Posters in Reims.

1897 First two solo exhibitions held in Paris at the Bodinière Gallery and then at the Salon des Cent.

1898 Initiated into the Grand Orient de France in Paris, the oldest Masonic organisation in France. Begins teaching at Whistler's Académie Carmen.

1899 Receives commissions from the Austro-Hungarian government for the Paris Exposition Universelle of 1900, including murals for the Bosnia-Herzegovina Pavilion (see pp. 54–59). During his research trip to the Balkans for this work the first seeds of the *Slav Epic* project are sown. *Le Pater* is published in Paris (pp. 52, 53).

1900 For his contribution to the 1900 Paris Exposition, awarded honours by both the Austro-Hungarian Empire and the French government (1901).

1901 Elected a member of the Czech Academy of Sciences and Arts. Designed by Mucha, Georges Fouquet's new jewellery shop opens in the rue Royale, Paris (pp. 60–61).

1902 Accompanies Auguste Rodin to Prague and Moravia on the occasion of the latter's exhibition in Prague. *Documents décoratifs* is published in Paris (pp. 62, 63).

1903 Meets a Czech art student and his future wife Marie (Maruška) Chytilová, who briefly studies at the Académie Colarossi and under Mucha.

1904 First visit to the US: paints society portraits following introductions by Baroness Adèle von Rothschild; meets Charles Richard Crane, a wealthy businessman from Chicago and Mucha's future sponsor for the *Slav Epic* project.

1905 Makes two more visits to the US, working on commissions and teaching at the New York School of Applied Design for Women. *Figures décoratives* is published in Paris.

1906 Marries Maruška in Prague on June 10. Fourth trip to the US, accompanied by Maruška. Mucha begins teaching at the Art Institute of Chicago.

1908 Commissioned to decorate the new German Theatre in New York (see p. 73). Brings up the idea of his *Slav Epic* project to Crane for the first time.

1909 Birth of daughter Jaroslava in New York. Summer vacation with his family in Bohemia and Moravia. Makes his fifth trip to the US: Crane agrees to finance Mucha's *Slav Epic*.

1910 Returns to Bohemia, where Mucha is engaged in the decoration of the Municipal House in Prague (see p. 78).

1911 Moves to Zbiroh Castle in western Bohemia to concentrate on the *Slav Epic* project.

1912 Travels through the Dalmatian region, accompanied by Maruška and his Moravian painter friend Joža Uprka. Completes the first three canvases of *The Slav Epic*.

1913 Sixth visit to the US. Makes an extensive research trip to Poland and Russia for *The Slav Epic*.

1915 Son Jiří is born in Prague.

1918 The independent state of Czechoslovakia is created as a result of the dissolution of the Austro-Hungarian Empire. Designs first postage stamps and bank-notes for the new state.

1919 First *Slav Epic* exhibition at the Klementinum in Prague shows five canvases (see pp. 80–81), which are then sent to America for exhibitions. Mucha's seventh and last visit to the US.

1920 Mucha's *Slav Epic* exhibition at the Art Institute of Chicago attracts 200,000 visitors.

1921 Retrospective at the Brooklyn Museum in New York features the five *Slav Epic* canvases, and is visited by 600,000 people. Mucha returns to Prague.

1923 Elected Sovereign Grand Commander of the Czech Supreme Council of Freemasons (right).

1924 Research trip to the Balkans for the remaining *Slav Epic* paintings. Publishes *Svobodné Zednářství* [Freemasonry] in Prague.

1928 The complete cycle of *The Slav Epic* is officially presented to the City of Prague by Mucha and Crane and is shown at the Trade Fair Palace in Prague.

1930 *The Slav Epic* is shown at the Exhibition Palace in Brno.

1931 Commissioned to design a stained-glass window to be donated by the Slavia Insurance Bank to St. Vitus Cathedral, Prague (see p. 13).

1932 Moves to Nice, living there for two years.

1933 Mucha exhibitions held in Pilsen, Hradec Králové and Chrudim.

1934 Promoted to Officier of the Légion d'honneur by the French government. Publishes *O Lásce, Rozumu a Moudrosti* [On Love, Reason and Wisdom] in Prague.

1936 Retrospectives at the Musée du Jeu de Paume, Paris, and the Moravian Museum of Decorative Arts, Brno. Begins to work on the triptych (unrealised) *The Age of Reason, The Age of Wisdom* and *The Age of Love*.

1939 German invasion of Czechoslovakia: Mucha is one of the first to be arrested and interrogated by the Gestapo on account of his Masonic activities. Although released after several days of questioning, his health is impaired by the ordeal. Mucha dies in Prague on July 14 and is buried at Vyšehrad Cemetery.

Self-portrait in formal Masonic regalia, as Sovereign Grand Commander of the Czech Supreme Council of Freemasons, 1923

Mucha in Red Square in Moscow, making sketches for *The Slav Epic: The Abolition of Serfdom in Russia* (1914), 1913

Select Bibliography
(Chronological Order)

Writings by Mucha

Alfons Mucha, "Br. Alfons Mucha (25 ledna 1898)", in *Stavba*, Prague, 1932, pp. 31–39

Alphonse Mucha: Lectures on Art, London/New York, 1975 (posthumous compilation of his lecture notes)

Monographs / Contextual Reading

Jiří Mucha, *Alphonse Mucha: The Master of Art Nouveau*, Prague, 1966

Graham Ovenden, *Alphonse Mucha Photographs*, London/New York, 1974

Ann Bridges (ed.) with Jiří Mucha, Marina Henderson and Anna Dvořák, *Alphonse Mucha: The Complete Graphic Works*, London, 1980

Jack Rennert and Alain Weill, *Alphonse Mucha: The Complete Posters and Panels*, Uppsala, 1984

Jiří Mucha with Takahiko Sano, Norio Shimada and Jun Watanabe, *Alphonse Mucha*, Tokyo, 1986

Jiří Mucha, *Alphonse Maria Mucha: His Life and Art*, London, 1989

Petr Wittlich, *Prague: Fin de Siècle*, Paris, 1992

Derek Sayer, *The Coasts of Bohemia: A Czech History*, Princeton, New Jersey, 1998

Dorothy Kosinski, *The Artist and the Camera: Degas to Picasso*, New Haven/London, 1999

Sarah Mucha (ed.) with Ronald F. Lipp, Victor Arwas, Anna Dvořák, Jan Mlčoch and Petr Wittlich, *Alphonse Mucha*, Zlín, 2000

Josef Moucha, *Alfons Mucha: Foto Torst Vol. 3*, Prague, 2005

Carol Ockman and Kenneth E. Silver (eds.), *Sarah Bernhardt: The Art of High Drama*, New Haven/London, 2005

Mucha Exhibition Catalogues

Brian Reade, *Art Nouveau and Alphonse Mucha*, London, 1963

Marc Bascou, Jana Brabcová, Jiří Kotalík and Geneviève Lacambre, *Alfons Mucha*, Paris, Darmstadt, Prague, 1980

John Hoole and Tomoko Sato (eds.), *Alphonse Mucha*, London, 1993

Karel Srp (ed.), *Alfons Mucha: Das Slawische Epos*, Krems, 1994

Sarah Mucha (ed.) with Petr Wittlich, *Alphonse Mucha: Pastels, Posters, Drawings and Photographs*, Prague, 1994

Norio Shimada and Petr Wittlich (eds.), *Alphonse Mucha: His Life and Art* (travelling exhibition in Japan 1995–1997), Tokyo, 1995

Petr Wittlich, *Alphonse Mucha and the Spirit of Art Nouveau*, Lisbon, 1997

Victor Arwas, Jana Brabcová-Orlíková and Anna Dvořák (eds.), *Alphonse Mucha: The Spirit of Art Nouveau* (US travelling exhibition 1998–1999), Alexandria, Virginia, 1998

Anna Dvořák, Helen Bieri Thomson and Bernadette de Boysson, *Alphonse Mucha – Paris 1900: Le Pater*, Prague, 2001

Milan Hlaváčka, Jana Orlíková and Petr Štembera, *Alphonse Mucha – Paris 1900: The Pavilion of Bosnia and Herzegovina at the World Exhibition*, Prague, 2002

Nobuyuki Senzoku (ed.) with Marta Sylvestrová and Petr Štembera, *Alphonse Mucha: The Czech Master of Belle Époque* (travelling exhibition in Japan 2006–2007), Tokyo, 2006

Àlex Mitrani (ed.), *Alphonse Mucha 1860–1939: Seducción, Modernidad, Utopía* (travelling exhibition in Spain 2008–2010), Barcelona, 2008

Jean Louis Gaillemin, Christiane Lange, Michel Hilaire and Agnes Husslein-Arco (eds.), *Alphonse Mucha* (Vienna, Montpellier, Munich 2009–2010), Munich/Berlin/London/New York, 2009

Marta Sylvestrová and Petr Štembera, *Alfons Mucha: Czech Master of the Belle Époque* (Brno, Budapest, 2009–2010), Brno, 2009

Tomoko Sato with Jeremy Howard, *Alphonse Mucha: Modernista e Visionario*, Aosta, 2010

Lenka Bydžovská and Karel Srp (eds.), *Alfons Mucha: Slovanská Epopej*, Prague, 2011

Tomoko Sato and Anna Choi (eds.), *Alphonse Mucha: Art Nouveau & Utopia*, Seoul, 2013

THE MUCHA FOUNDATION

The Foundation was established in 1992 following the death of Alphonse Mucha's son, Jiří, by his wife, Geraldine, and their son, John. The Foundation is an independent, non-profit-making charity, the core aims of which are to preserve and conserve the Mucha Family Collection and to promote the work of Alphonse Mucha.

The Mucha Family Collection is the largest and most comprehensive body of works by Alphonse Mucha in the world and is representative of all aspects of his artistic achievement, including lithographs, paintings, pastels, photographs, sculptures, jewellery, drawings and more. The collection also includes the most complete archive of the artist's correspondence and writings.

The Mucha Foundation is committed to presenting the broadest possible vision of Mucha, an artist best known as the supreme exponent of Art Nouveau, whose decorative works are landmarks in the history of modern graphic art, but whose artistic concerns embraced so much more than 'mere decoration'. Mucha believed passionately that art was an essential benefit to humanity and that it should be seen and enjoyed by as many people as possible. The Mucha Foundation continues his legacy by actively promoting his work through worldwide exhibitions, a publications programme and the Mucha Museum in Prague.

To date the Foundation has been the lead contributor to, and a moving spirit behind, more than 100 major Mucha exhibitions held throughout Europe, Asia and the United States. Additionally, the Foundation cooperates with museums and lends works to many exhibitions worldwide. In 1998, a long-held dream was realised with the opening of the Mucha Museum in the Kaunický Palace in the centre of Prague. It is now one of the most successful museums in the city, welcoming over 100,000 visitors every year.

For news about the Foundation, its exhibitions, a gallery of works by Mucha as well as an interactive timeline of his life, please follow us on Facebook and visit the Mucha Foundation website at www.muchafoundation.org.

**EACH AND EVERY TASCHEN BOOK
PLANTS A SEED!**
TASCHEN is a carbon neutral publisher. Each year, we offset our annual carbon emissions with carbon credits at the Instituto Terra, a reforestation program in Minas Gerais, Brazil, founded by Lélia and Sebastião Salgado. To find out more about this ecological partnership, please check: www.taschen.com/zerocarbon
Inspiration: unlimited. Carbon footprint: zero.

To stay informed about TASCHEN and our upcoming titles, please subscribe to our free magazine at www.taschen.com/magazine, follow us on Twitter, Instagram, and Facebook, or e-mail your questions to contact@taschen.com.

This publication has been made in collaboration with the Mucha Foundation. Unless stated otherwise, all images in the book are from the Mucha Family Collection and owned by the Mucha Trust © Mucha Trust 2015.

© for the work of František Kupka: VG Bild-Kunst, Bonn 2015: p. 15
© photo: Moravian Gallery, Brno: p. 10
© photo: National Gallery, Prague 2015: p. 67
© photo: Roger-Viollet: pp. 60–61
© photo: Thomas Goldschmidt; Badisches Landesmuseum, Karlsruhe: p. 50

PAGE 2
Mucha with Sarah Bernhardt posters at his studio in the rue du Val-de-Grâce, Paris, *c.* 1901

PAGE 4
Rêverie (variant), 1898
Colour lithograph, 72.7 x 55.2 cm /
28⅝ x 21¾ in.

© 2015 TASCHEN GmbH
Hohenzollernring 53, D–50 672 Köln
www.taschen.com

Project management: Ute Kieseyer, Cologne;
Petra Lamers-Schütze, Cologne
Coordination: Christine Fellhauer, Düsseldorf
English revision: Chris Allen, London
Production: Tina Ciborowius, Cologne
Design: Birgit Eichwede, Cologne
Layout: Claudia Frey, Cologne

Printed in Slovakia
ISBN 978-3-8365-5009-3